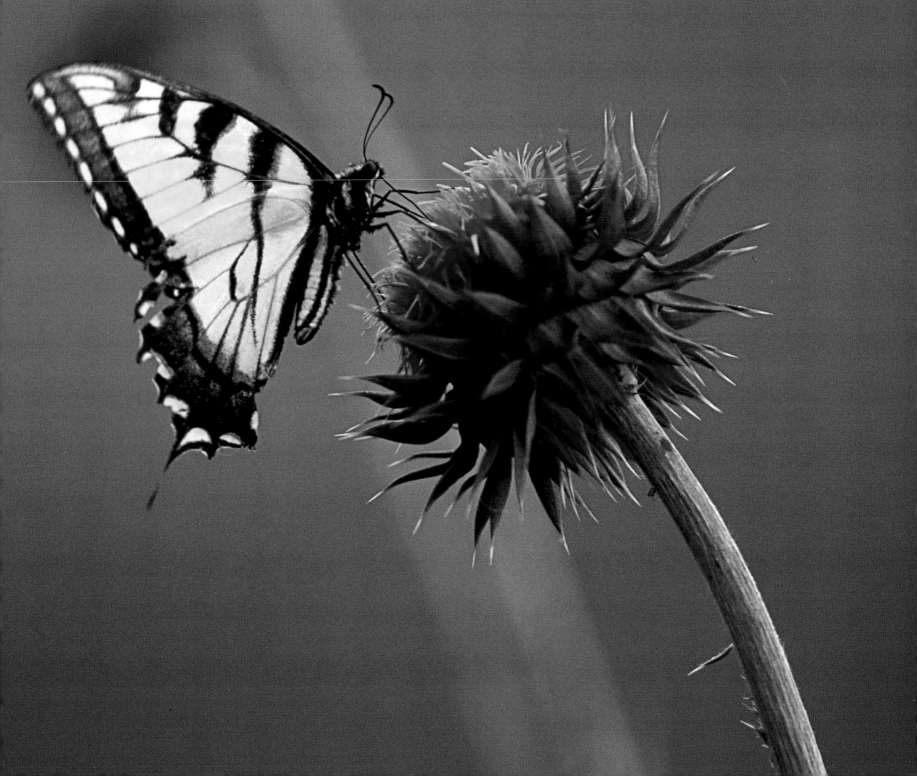

Dedicated to everyone who had the foresight

to protect Scott's Gulf for future generations to enjoy.

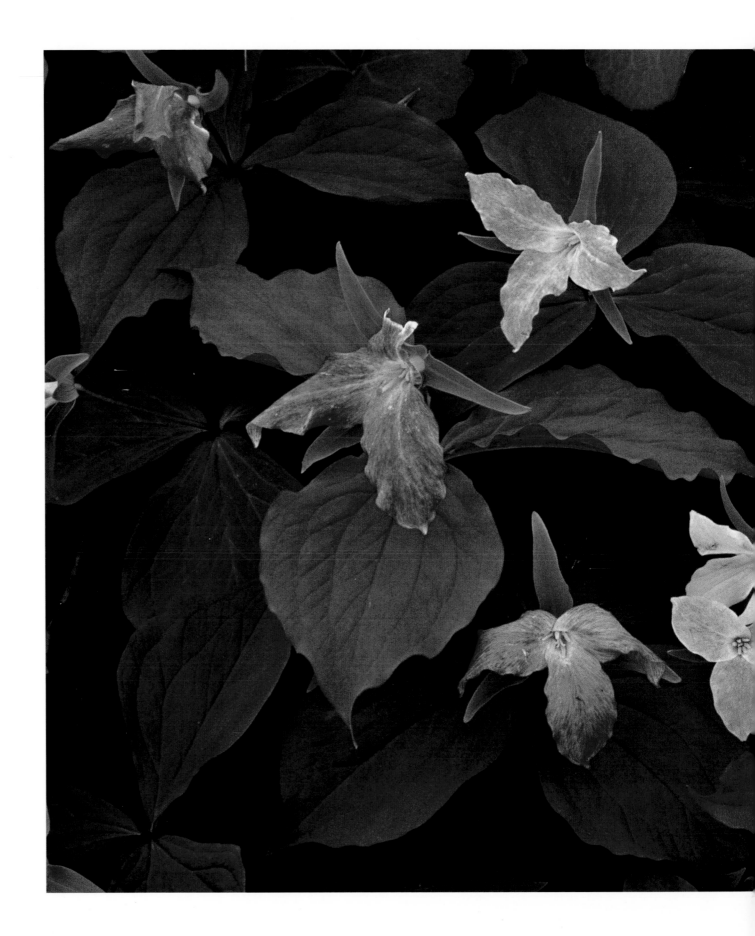

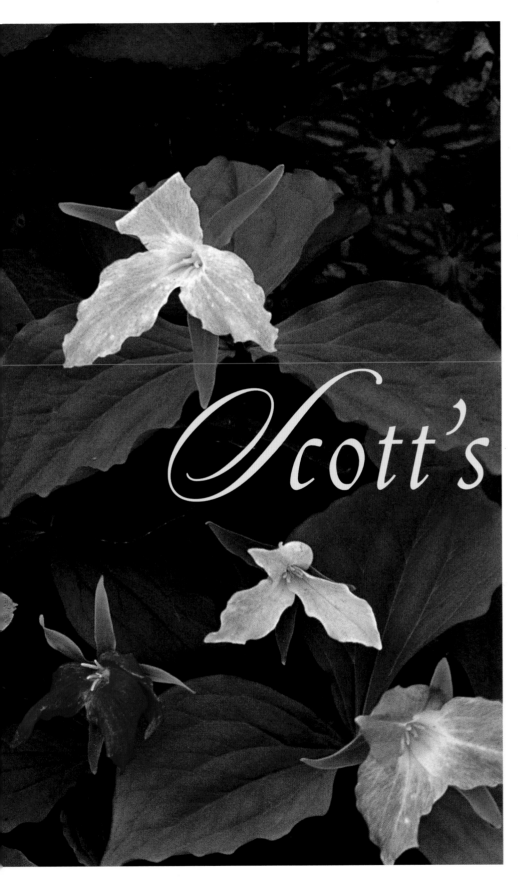

Scott's Gulf

The Bridgestone/Firestone Centennial Wilderness

BY SENATOR HOWARD BAKER
AND JOHN NETHERTON

FOREWORD BY
GOVERNOR
DON SUNDQUIST

ACKNOWLEDGMENTS

Many people played an important role in making the Bridgestone/Firestone Centennial Wilderness a reality, and we would like to extend a very heartfelt thank-you to all of them for their dedication and hard work. We are especially grateful to the following individuals for their personal efforts or their assistance with this book: Lee Altieri, David Badger, Tim Bent, Rex Boner, Bill Bryant, Glenda Bryant, Clarence Coffee, Carl Cude, Frank Doman, Steven M. Elrod, Richard Erdmann, Pete Ezell, Milton Hamilton, David Harbin, Trevor Hoskins, Peggy Jones, Christine Karbowiak, Judy Layne, Wilbert Layne, Tom A. Lesher, Jack Lynn, Fred Marcum, Matthew Martie, Melissa McGuire, Ed Menzie, Gary Meyers, Jill Miller, Duke Nishiyama, Masatoshi Ono, Jean Pompa, Victoria Rainone, Jim Range, Reggie Reeves, Nancy Rice, Kenji Shibata, Trig Sims, Don Smith, Frank Smith, Joseph Smith, Bob Steele, Governor Don Sundquist, Reid Tatum, John Turner, Suzanne Venino, Jim Vines, Justin Wilson and Maryann Wilson.

—H.B. and J.N.

International Standard Book Number: 0-9677827-0-8
Library of Congress Card Catalog Number: 99-85834

Photography © 2000 John Netherton. All rights reserved.
Photography © 2000 Howard Baker. All rights reserved.
Editors: David Badger and Suzanne Venino
Designer: Nancy Rice, Nancy Rice Graphic Design, Denver, Colorado
Packaged by: Suzanne Venino Editorial Services, LLC, Boulder, Colorado

Published by Rogue Elephant Press
Nashville, Tennessee
(615) 371-8012

Printed in Hong Kong

Page 1: A tiger swallowtail alights on a thistle flower.
Previous page: Large-flowered trillium brighten the forest floor.

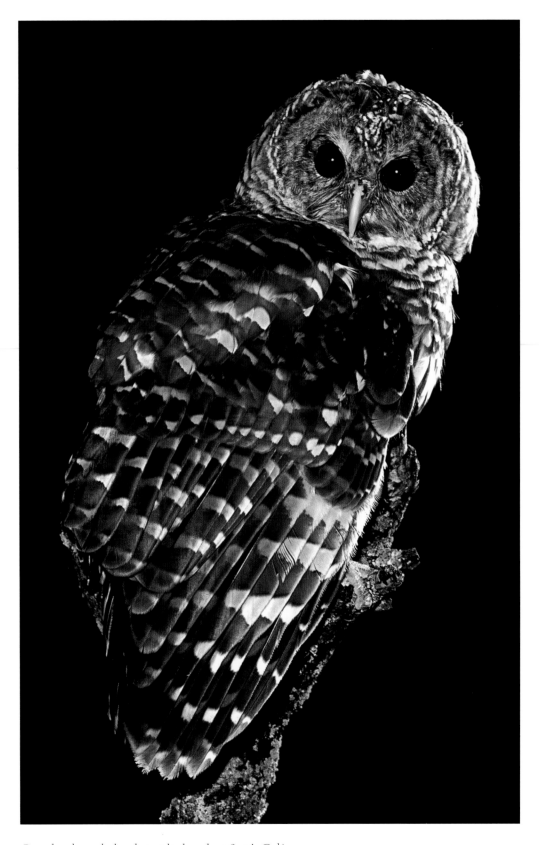

Barred owls can be heard at night throughout Scott's Gulf.

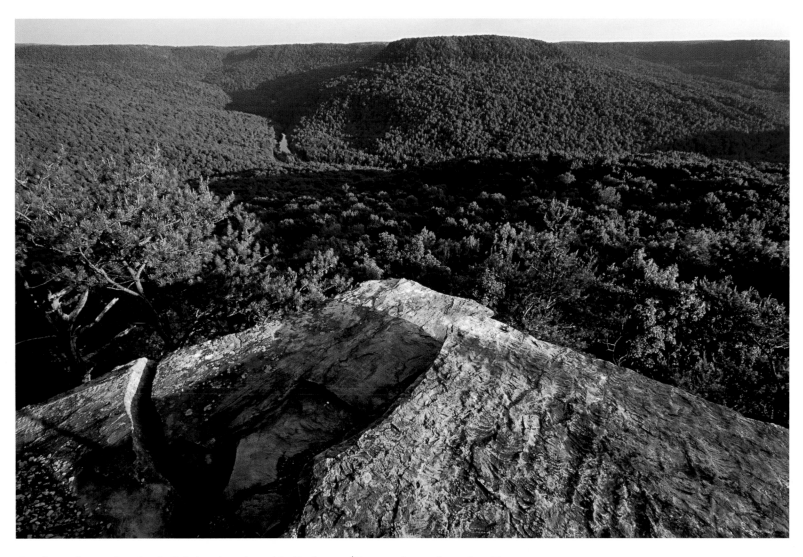

Ten thousand acres along Scott's Gulf have been donated by Bridgestone/Firestone, Inc. to the people of Tennessee.

PRESERVING OUR INHERITANCE

It has been said that mankind does not exist apart from nature; rather, we are part of it. For thousands of years, the natural resources of the territory we now know as Tennessee have rewarded a variety of inhabitants with a rich and wondrous life. As the sun rises on the twenty-first century, the breathtaking beauty of this land needs to be preserved for future generations. Within the pages of this splendid book, my friends Howard Baker and John Netherton bring to light the magnificent natural gifts, seldom seen by most of us, of one of Tennessee's rare wilderness treasures.

Heirs to this land's natural bounty and beauty, Tennesseans today possess an obligation to protect and preserve our inheritance. If we are indeed part of this natural balance, then our investments in support of economic opportunity and the advantages of modern life must be accompanied by equal efforts to sustain and replenish the natural environment.

Mindful of this delicate accord between progress and preservation, and in a gesture of strong civic leadership, Bridgestone/Firestone Chairman Masatoshi Ono—on behalf of more than 4,000 employees in Tennessee—has generously endowed the state with one of nature's most highly prized heirlooms. The pristine land within the acreage of the Bridgestone/Firestone Centennial Wilderness—a protected oasis along Scott's Gulf, near Chestnut Mountain in Middle Tennessee— remains today much as it was when ancient tribes and early settlers came over the mountains and down the rivers of a rugged frontier territory. In transferring the deed of this rare and unspoiled gem to our state, Chairman Ono has assured its protection and preservation long after we have passed from the scene.

This generous and lasting endowment to our state and to our citizens is an example of the many benefits the people of Tennessee derive from Bridgestone/Firestone's responsible corporate citizenship. We are proud indeed that Bridgestone/Firestone chooses to call Tennessee home. We value the company's confidence in us, and we value its contributions to the health of our economy. We value the philanthropic giving and support to the arts for which the company is widely respected and acknowledged. In so many ways, Bridgestone/Firestone leads by example, showing the rewards of partnerships between individuals and institutions who care deeply about our shared future.

I am grateful for this generous donation and the knowledge that this treasure will endure. Thanks to Bridgestone/Firestone and the Conservation Fund, survival is now guaranteed for a rare natural wilderness and the diverse species it supports. And, in the long term, vital connections to the land will be preserved for those who seek refreshment for body and spirit in the tranquility of nature's unrivaled display.

DON SUNDQUIST
Governor of Tennessee

A Jewel of a Property

When Bridgestone acquired the Firestone Tire & Rubber Company in 1988, it joined with a remarkable company that had a heritage stretching back to 1900. It also acquired an even more remarkable asset—a jewel of a property consisting of thousands of acres of unspoiled wilderness on the Cumberland Plateau that Firestone had been assembling for many years.

The natural beauty of this property rivals any you will see in Tennessee, or, for that matter, anywhere in the United States. As Governor Sundquist and John Turner state in their comments to this book, the property is a spectacular combination of meadows, mountains, hardwood forests, pasture land, stretches of white-water river, scenic bluffs, caves and gorges. A wide variety of wildlife, including a number of rare and endangered species, are at home in Scott's Gulf. We are honored to have been the stewards of this property for almost thirty years, and we are proud to present approximately 10,000 acres of this magnificent land to the state of Tennessee. This treasure will now be preserved for generations through a unique collaboration between the state, the Conservation Fund and Bridgestone/Firestone. It is our goal that future generations who visit the Bridgestone/Firestone Centennial Wilderness will find this land as beautiful and unspoiled as is reflected on these pages.

In this year of the Firestone Centennial, as we pause to reflect on our history and look to our future, we are grateful to Senator Howard Baker and John Netherton for capturing the vitality and wonder of Scott's Gulf in the photographs of this book. It is a message to future generations that we who preceded them understood and respected the importance of preserving natural areas such as this, and it is a call for them to do the same.

We at Bridgestone/Firestone wish to thank Governor Don Sundquist, whose vision recognizes the importance of a balance between economic development and the need to preserve the scenic beauty of this state. His assistance in creating the partnership between our company, the Conservation Fund and the state will leave a testament to his leadership that will endure for years and years to come. We also wish to thank John Turner and the many people at the Conservation Fund who have worked tirelessly with us on the many details that attend a project of this size and scope.

We at Bridgestone/Firestone are proud to call Tennessee home, and are pleased that we are able to contribute to its future.

Masatoshi Ono
Chairman and CEO
Bridgestone/Firestone, Inc.

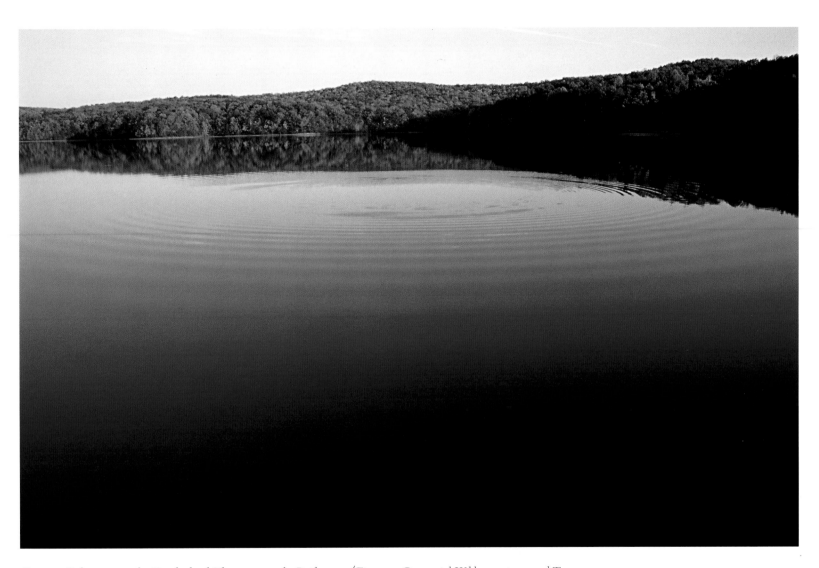

Firestone Lake sits atop the Cumberland Plateau, near the Bridgestone/Firestone Centennial Wilderness in central Tennessee.

A LEGACY FOR THE NEXT MILLENNIUM

Hidden deep in a remote area of Tennessee's Cumberland Plateau is one of America's most spectacular forested river canyons—the Caney Fork River Gorge. Known locally as Scott's Gulf, this breathtaking landscape, which is certainly of national park quality, has recently been made public through a generous gift by Bridgestone/Firestone, Inc. to the citizens of Tennessee and the nation. To be managed as a state wildlife and wilderness area, the Bridgestone/Firestone Centennial Wilderness is an outstanding corporate donation that will be enjoyed for generations.

Join Senator Howard Baker and John Netherton on a trek through this special wilderness. Through the lenses of these skilled photographers—two native Tennesseans who know and love their state's out-of-doors—you'll enjoy this rugged twelve-mile stretch of the Caney Fork, its hidden cascades and its dramatic waterfalls. One of the most diverse hardwood forests remaining in the world, Scott's Gulf supports rare plant species and harbors habitat niches that are home to endangered species and myriad wild animals.

You'll experience Scott's Gulf through the seasons, from the vivid palette of fall colors to a snow-hushed forest, from delicate spring flowers to a summer sunrise on Firestone Lake. You'll wander through meadows, visit secluded fishing holes and venture out onto sandstone cliffs overlooking the river corridor. You'll see Native American petroglyphs etched into rock, and reflect upon the early settlers who pioneered a way of life in this rugged land. Or you can simply relax and enjoy the serenity of nature.

Through the pages of this book, you too can experience Scott's Gulf, for this portfolio of images celebrates its scenic beauty and human history, providing a legacy for the next millennium.

JOHN TURNER
President and CEO
The Conservation Fund

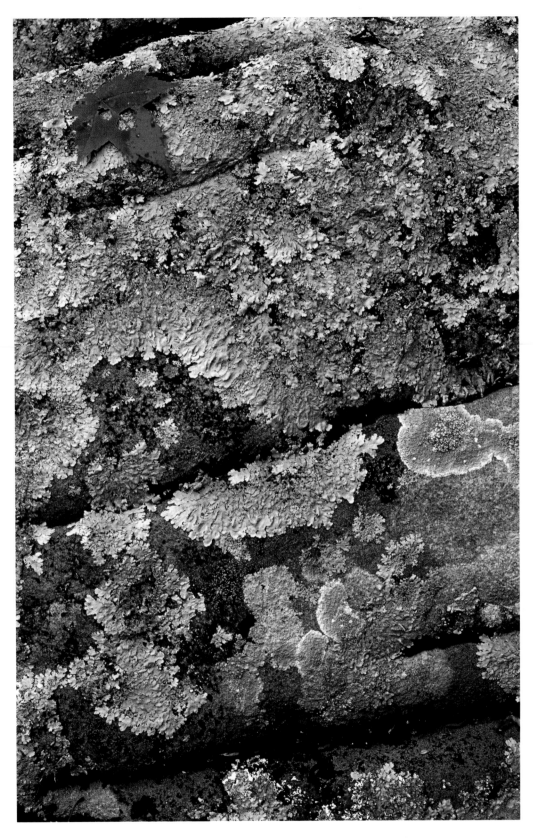

Over time, slow-growing lichens will gradually wear down rock.

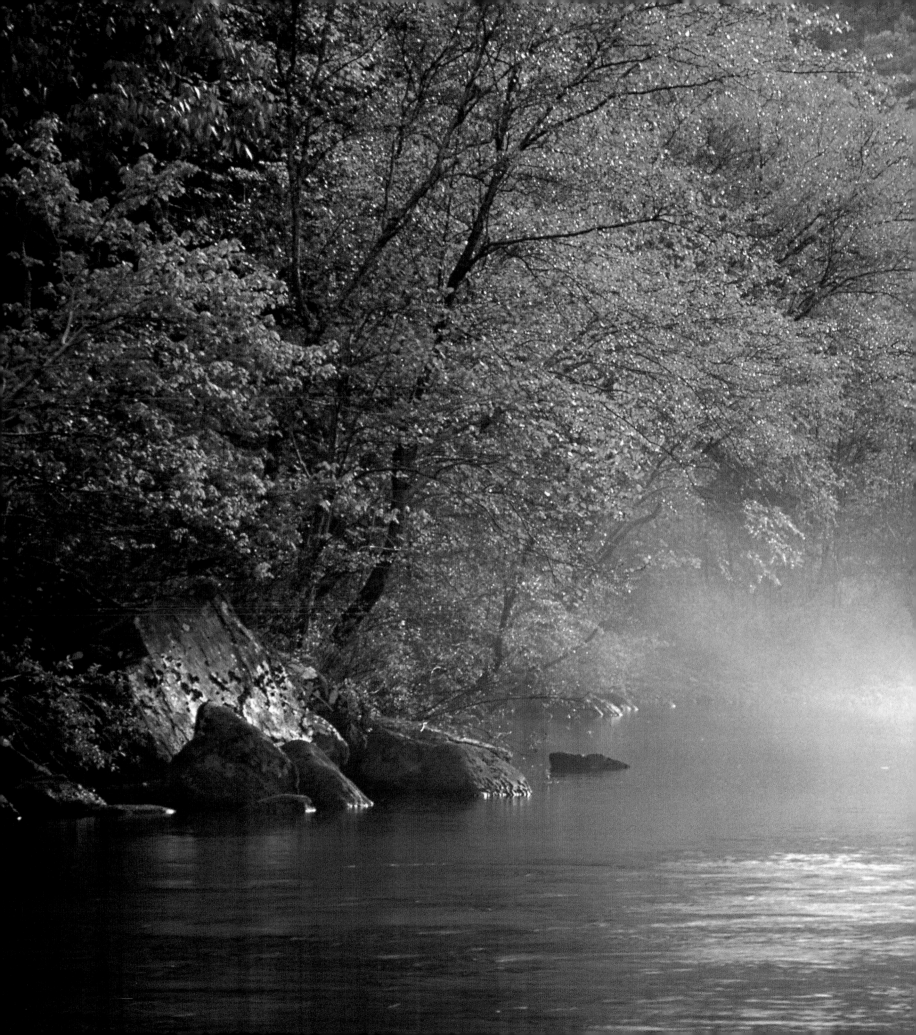

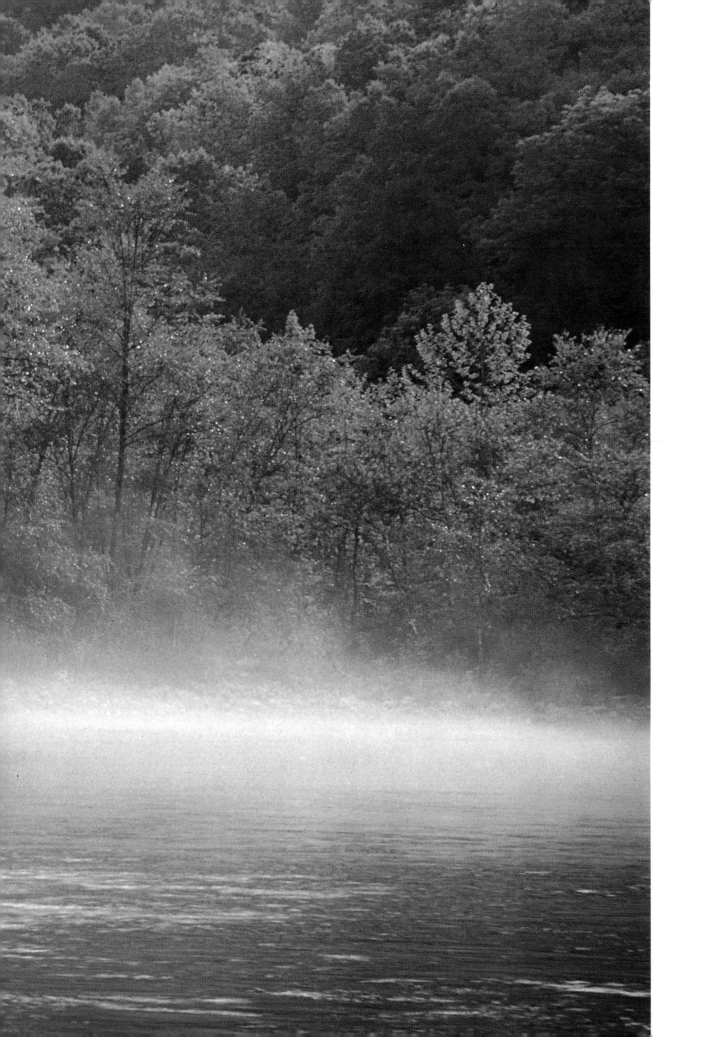

The Caney Fork River flows twelve miles through Scott's Gulf.

13

Scott's Gulf

THE BRIDGESTONE/FIRESTONE CENTENNIAL WILDERNESS

From atop Yellow Bluff a visitor might find it hard to imagine that the wilderness below, bathed in the warm glow of the sun, was once a thriving community on the Caney Fork River. Known as Scott's Gulf, this area has not been logged for over a generation. As far as the eye can see, these 10,000 acres atop the Cumberland Plateau—a gift from Bridgestone/Firestone, Inc.—serve as an important link in establishing a corridor of undeveloped lands, not only for wildlife and migrating birds but also for Tennesseans who go to the woods for what Henry David Thoreau once called the "tonic of wildness." The people who have grown up along the river know that tonic and have for the most part stayed close at hand. Fishing the Caney Fork's waters is as much a tradition as going to church on Sunday.

The Cumberland Plateau is a flat, fifty-mile-wide geological formation that runs parallel to the Appalachian Mountains to the east and rises a thousand feet above the Highland Rim to the west. It is part of the larger Appalachian Plateau, a tablelike shelf that stretches along the western edge of the Appalachian Mountains from New York to Alabama. Part of the Cumberland Plateau, Scott's Gulf is located eighty miles southeast of Nashville. It boasts overlooks with colorful names such as Bald Point and Buzzard's Roost, where a visitor standing on a precipice a thousand feet above the river can watch vultures riding the warm thermals. At first, the vultures look like small songbirds gliding in the gorges below, but, as they rise slowly on the warm air, they come virtually face to face with anyone standing on Buzzard's Roost. Then, with a tilt of their wings, the vultures soar toward the sun and vanish from sight.

In mid-April the hillsides near Polly's Branch Falls are covered with large-flowered trillium, pink lady's slippers, foamflower and mayapple. By the end of the month, Indian pink, crested dwarf iris and many varieties of violets will be blossoming along the Caney Fork. Mountain laurel line the riverbanks, littering the ground with their delicate blossoms, dropped one by one as the season passes. After a good rain, fungi of every description push through the leaf litter, and ferns grow thick throughout the forest's understory.

The earliest inhabitants of this area apparently lived during the Woodland and Mississippian periods (approximately 1000 B.C. to A.D. 500 and 600 B.C. to A.D. 1400, respectively). Native peoples etched symbols into sandstone walls, where shards of pottery and arrowheads have also

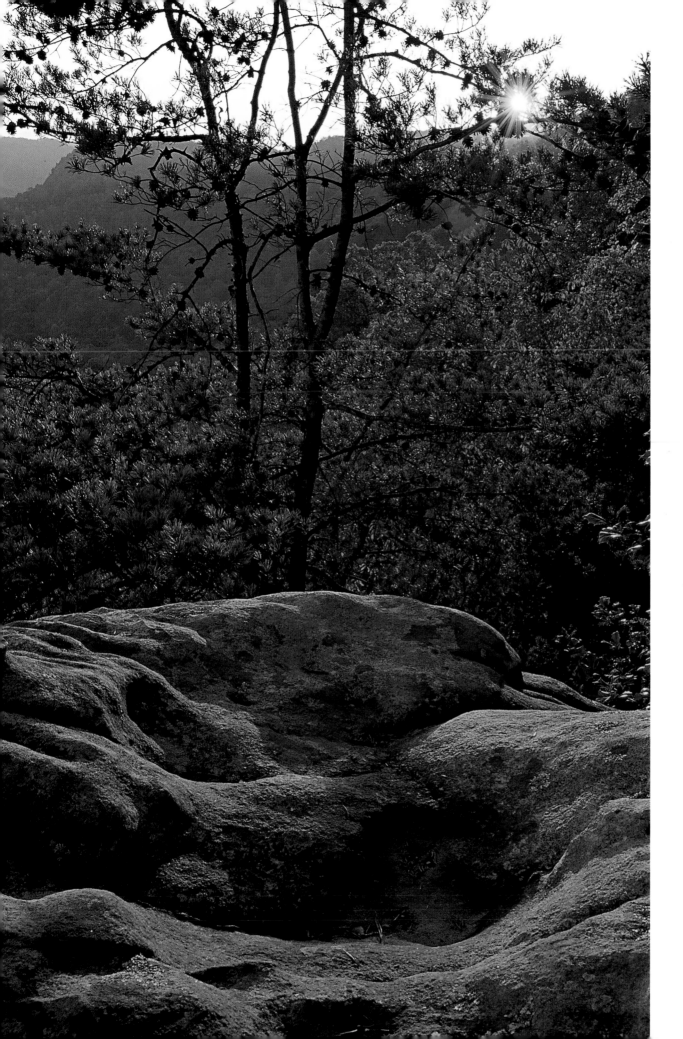

Rock depressions atop Yellow Bluff reflect the warm light of the setting sun.

15

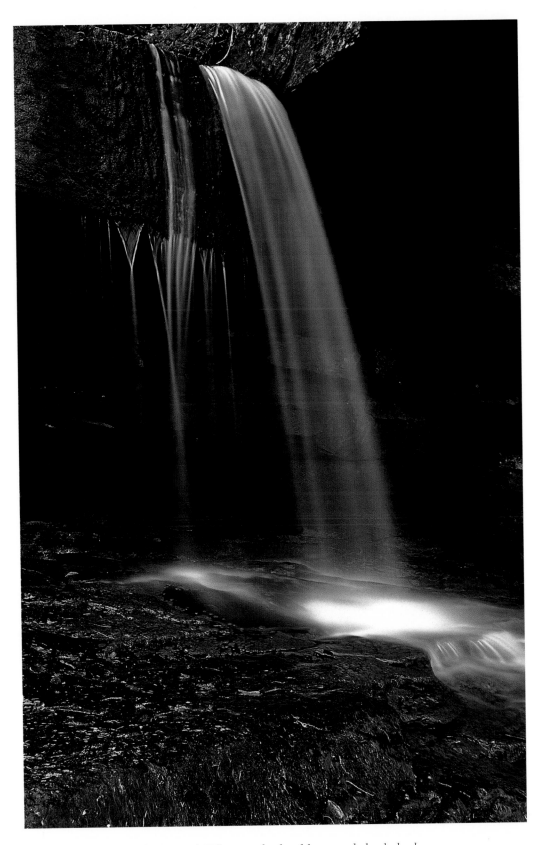

Many areas, such as Panther's Branch Falls, are isolated and known only by the locals.

been found. The Cherokee lived here too, migrating in and out of the gorge. When the first white settlers arrived, not all of the plateau was covered by heavy forest, for the Cherokee had burned selected areas to keep open fields of grasslands.

There are several variations on the first name of the patriarch of the family that settled the area around 1790—then not yet the state of Tennessee but still a territory. He was called Micager by his great-great-granddaughter. A point is named McCager but everyone nowadays says Cager. Cager Scott—as we shall refer to him—settled here along with the Welch family and the Davises (the latter in larger numbers). Families were often quite large back then; Cager's son Jack, for example, had sixteen children. Scott Pinnacle rises above the site where Cager built his family's cabin, and the family cemetery can still be seen at Scott Point. The headstones are rough and few legible names remain.

On the other side of the Caney Fork is the Davis cemetery, where "comb" gravestones can be found. Unique to the eastern Highland Rim and sections of the plateau, comb gravestones con-

sist of two rectangular-shaped slabs of sandstone (or sometimes limestone) that lean against one another to create a tent shape. There are several explanations offered for these unusual gravestones. Some sources say the slabs kept the graves dry, while others say they protected the sites from livestock or wild animals. Gravestones of this type, so dominant in the Davis cemetery, were constructed for the most part between 1820 and 1930, and can even be found northward into Kentucky. The Scott cemetery, strangely, does not have any.

The Scotts, as their name suggests, were originally from Scotland. Some speculate they also may have had a mix of Cherokee. Many people believe that the Gulf was a haven for the Cherokees who escaped President Andrew Jackson's forced march from Georgia to Oklahoma in 1838, which became known as the Trail of Tears. People of Scottish, Irish and Cherokee heritage ultimately inhabited much of the area, and today there are still second-generation residents from Scotland found here.

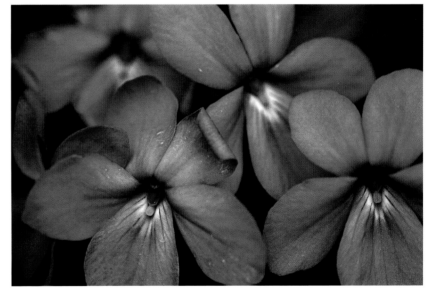

Violets bloom in April along the banks of the Caney Fork River.

At one time the river supported a thriving community. Several schools (one of which was constructed from a single poplar), lumber mills, a boarding house and numerous homesteads filled the gorge where today the only evidence of their existence is a few moss-covered stone walls. The timber industry did well in the Gulf for years. "Trees so tall you couldn't shoot a squirrel out of

the top of them," is the way Frank Smith describes the enormity of the trees fifty and sixty years ago. Chestnut, poplar, hemlock, red oak, white oak, hickory, Virginia pine and white pine all stood tall. The edible nuts of "scatter bark" hickory and chestnut trees were so plentiful that residents of the Gulf would gather them by the sackful. Livestock roamed free, feeding on nuts and grasses. Every year, the locals burned off areas to produce fresh grass for their cattle.

Harvesting ginseng, goldenseal, mayapple and yellow root allowed residents to supplement their income. The dried roots were taken to a fellow who worked out of his truck in front of a grocery in Eastland, buying from people who came from surrounding counties. He would then pack up the herbs in a barrel and ship it overseas.

It was the Great Flood of 1929 and the Great Depression (1929-1934) that destroyed an entire way of life in the Gulf. Thereafter, it would be much easier to earn a living working in the coal mines. Yet even after most people had finally moved away from the Caney Fork, Scott's Gulf

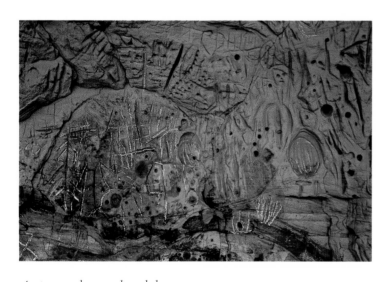

Ancient peoples carved symbols into sandstone, here marked with archeologists' chalk.

was still a source of food. From the age of six, Frank Smith accompanied his father on weekends as they walked six or seven miles into the Gulf to catch fish and hunt squirrel to provide food for their family. Camping in the Gulf didn't mean sleeping in a tent and a sleeping bag; it simply involved gathering enough leaves and branches to cover and protect oneself on the bitterly cold nights. Ammunition was expensive, so every shot had to count. (Many an herb was dug in order to buy these precious shells.) Watermelons continued to grow along the river bottom, even though gardens had been abandoned years earlier.

It is interesting to fish along the Caney Fork with Frank Smith and his two brothers, Joseph "Dude" and Don. They know which holes to fish and when. They can tell you what species you are likely to find in each area and the best bait to use, whether it's a "catawbi worm," a minnow or a crayfish. Red-eye, smallmouth bass, bream, largemouth bass and catfish swim the clear green waters of the Caney Fork, which flows twelve miles through the Gulf. The upper Caney Fork is mostly a "wet-weather river," going underground at the place locals call The Sinks. You can stand atop Buzzard's Roost and hear the sounds of the river "falling." It reappears near Bee Creek—actually a small river—which flows into the Caney Fork and increases the size of the waters. In the winter and early spring, when there is generally considerable rainfall, the river becomes Class V white water and is used by kayakers and canoeists.

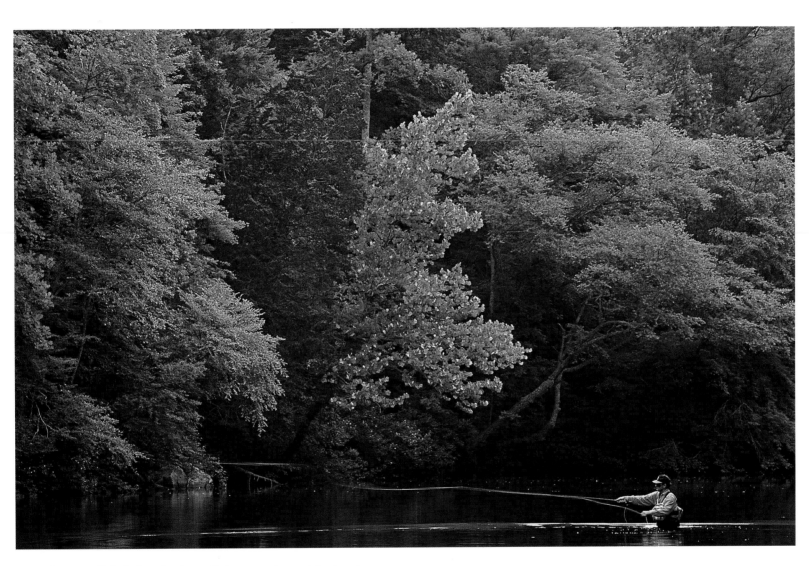

Areas known as "holes" along the Caney Fork are popular with local anglers.

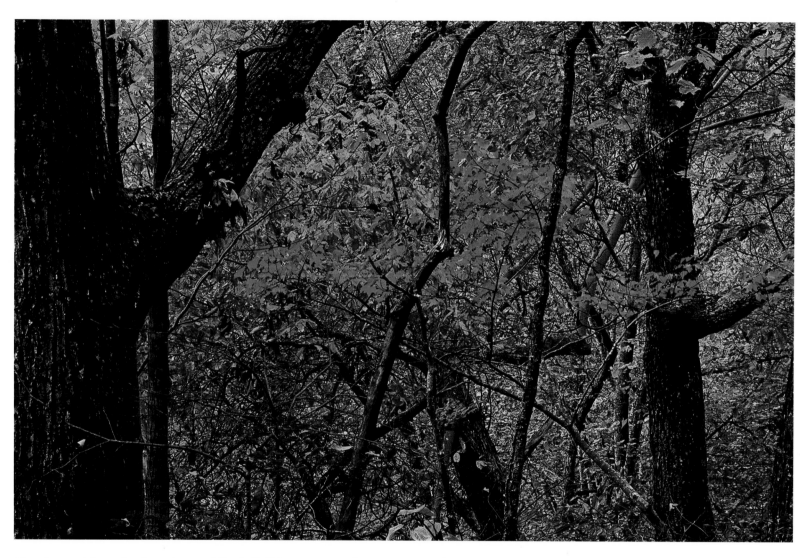

Once harvested for timber, forested areas of Scott's Gulf have gone virtually uncut for more than a generation.

Waterfalls with names such as Panther's Branch Falls, Polly's Branch Falls and Bee Branch Falls are known to but a few people, for there are few real trails leading to these sites. In fact, there are still waterfalls in the Gulf that have yet to be named. And then there is Big Springs. With a steep bluff as a backdrop, it is a beautiful clear-blue hole celebrated for its trout and smallmouth bass.

There are also many caves and rock shelters throughout the Gulf. Rose Cave, probably the best known, is eighty feet wide and fifty feet high and home to federally endangered Indiana and gray bats. Rose Cave was named for a woman who supposedly entered the cave with her husband—never to be seen again. The Eastern pippestrille bat is common in area caves, and Rafinesque's big-eared bat has been found in some of the smaller caves. Beautiful formations, along with impressive stalactites and stalagmites, are still intact in a number of lesser-known caves.

Cows once grazed Chestnut Mountain Ranch, now managed to provide food and habitat for native wildlife.

Once extensively hunted, wildlife is plentiful again in Scott's Gulf. Barred owls can be heard calling back and forth in the evening along Yellow Bluff, their hooting echoing across the gorge. Great horned owls call too, their sound more deliberate and deep, while the Eastern screech owl produces an almost melancholy sound. No wonder early settlers developed deep superstitions about night sounds such as these. The lesser-known but equally vocal barking tree frog—as well as other species of frogs and salamanders—can be found here too, especially on rainy nights. Deer, bobcat, red and gray foxes, wild turkeys, raccoons and opossum also thrive in the Gulf.

It was a man named Mose Sims who convinced the Firestone Tire & Rubber Company to purchase first the Chestnut Mountain Ranch and later even more land, for a total of 15,200 acres atop the Cumberland Plateau, of which the largest part is called Scott's Gulf.

Harold Mose Sims lived the sort of life that most people only read about. A native of Sparta, Tennessee, he traveled the world in the Foreign Service under presidents from Franklin Delano Roosevelt to John F. Kennedy. During World War II he was cited for his work helping to break up German and Italian spy rings in South America. Although his travels took him around the world many times, Mose eventually returned home to White County and was elected mayor of Sparta. In 1963 he joined Firestone as a special adviser for international relations. Even after he retired, Mose was hired back to oversee Scott's Gulf for Firestone and later for Bridgestone/Firestone.

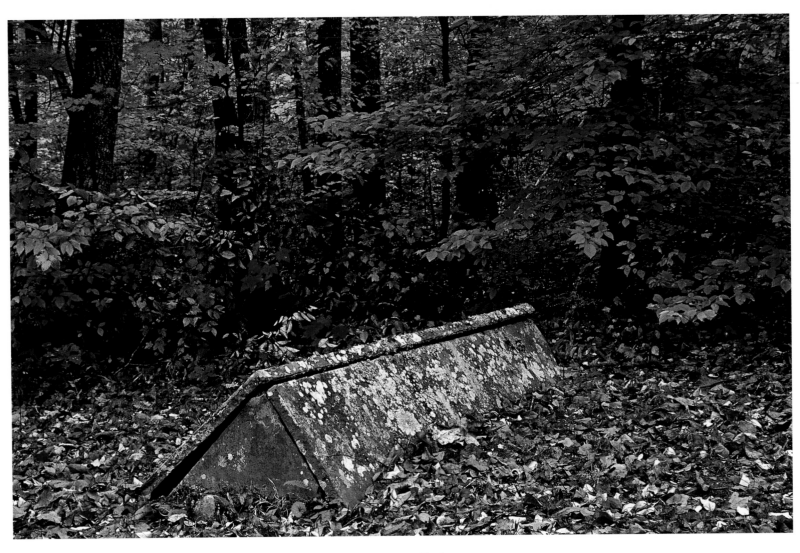

Tent-shaped "comb" gravestones are unique to the Cumberland Plateau and eastern Highland Rim of Tennessee.

In 1966, Governor Buford Ellington sent a delegation to meet with Mose Sims to consider Scott's Gulf as a possible park. At the time, however, Savage Gulf to the south was considered a higher priority and it was purchased instead. One of the state's more popular parks, Fall Creek Falls, lies just south of Scott's Gulf. With more than a million visitors to Fall Creek Falls each year, the addition of the Bridgestone/Firestone Centennial Wilderness will provide a haven for hikers wishing to experience a quieter, less crowded area.

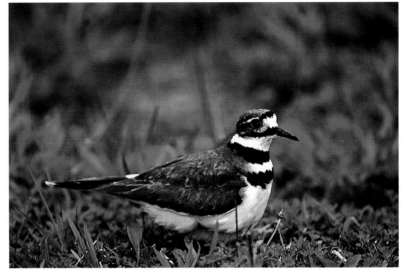

Bill Bryant, the youngest of thirteen children, is another individual who has been a part of the Gulf all his life. Bill inherited Mose Sims' position overseeing the property, and along with Wilbert Layne, has protected the wildness of the Gulf by fighting fires and enforcing regulations. Working with Tennessee Wildlife Resources officers, Bill has been charged with making sure that hunters and fishermen stay within the proper guidelines and limits of the season. Like most of the people around Scott's Gulf, Bill understands the importance of an area of this nature. He grew up with the Gulf in his backyard, as did his wife, Glenda. Today he is dedicated to ensuring that his children and their children will have a place to nurture the soul.

A killdeer sits on her nest, incubating four speckled eggs.

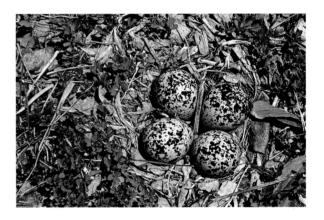

Scott's Gulf consists of 10,000 acres of breathtaking wilderness, generously donated to the people of Tennessee by Bridgestone/Firestone, Inc. The farsighted efforts of this company—working in conjunction with the Conservation Fund and the state of Tennessee—should serve as a model of how corporations and citizens can work cooperatively to protect some of the last stands of wilderness in the eastern United States. The property, officially designated the Bridgestone/Firestone Centennial Wilderness, will be managed by the Tennessee Wildlife Resources Agency. Chestnut Mountain Ranch, used at one time for cattle, is now managed to provide suitable habitat and food for native wildlife. Just as throughout the long history of Scott's Gulf, there will still be hunting and fishing here. Hikers and photographers will have a quieter, less crowded area to enjoy. And all Tennesseans will be able to sample the "tonic of wildness" that everyone in Scott's Gulf has enjoyed for generations.

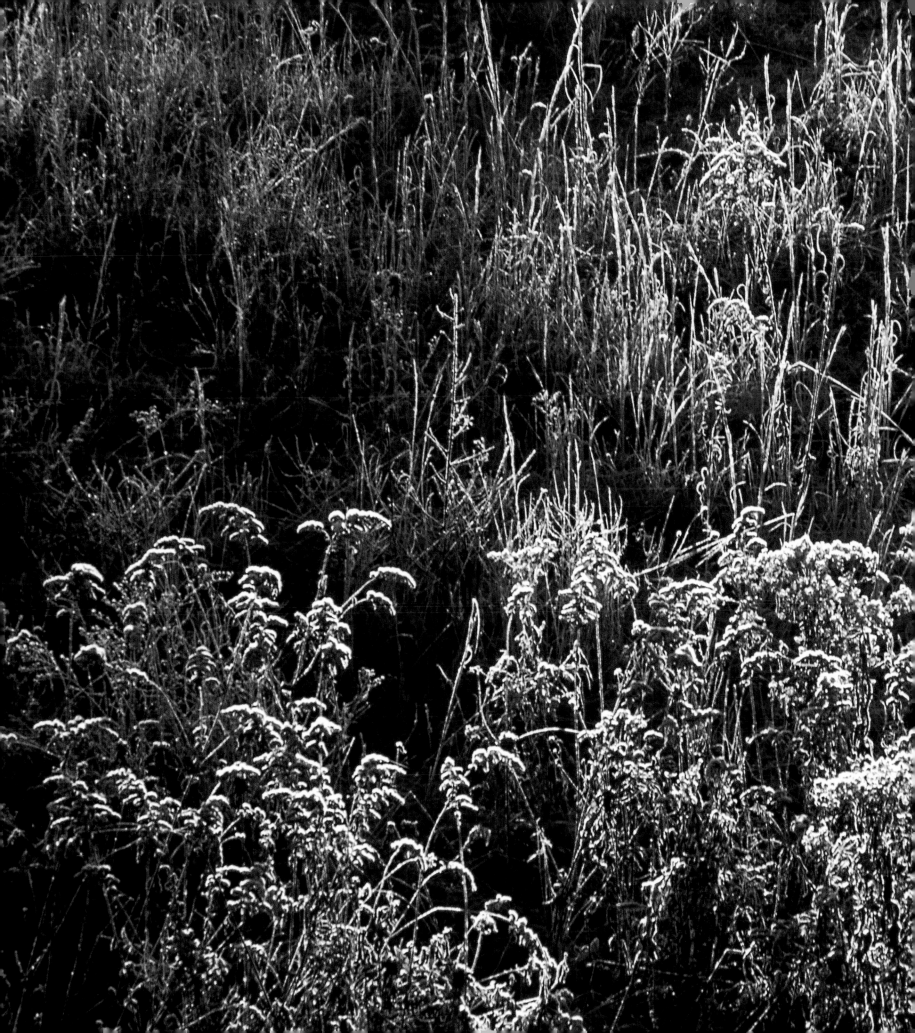

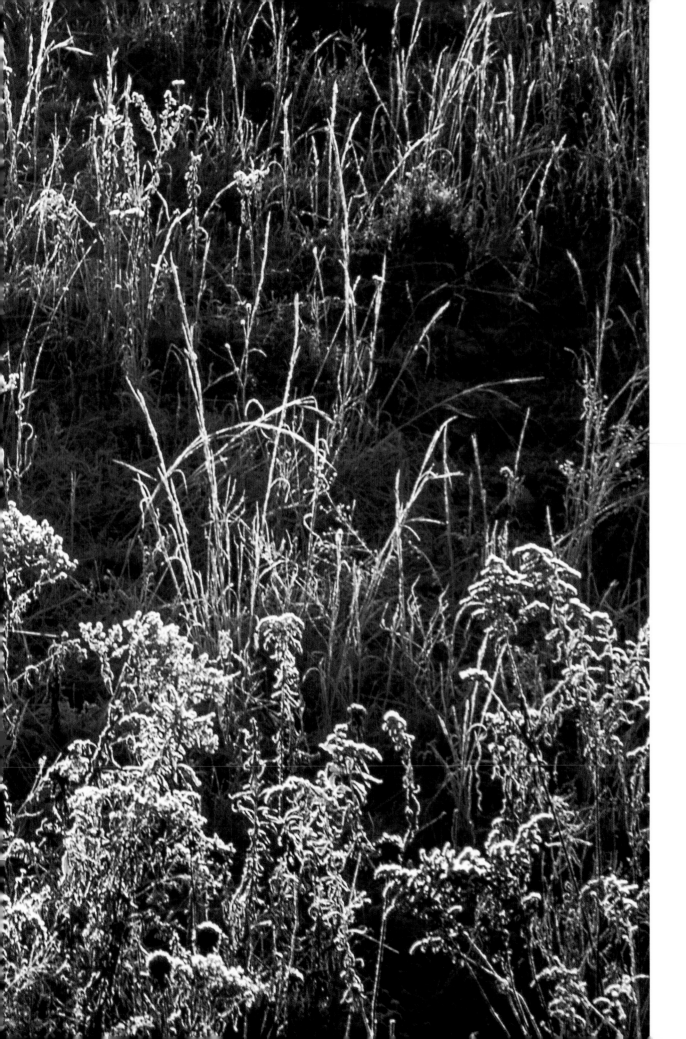

Frost covers a field of dried grasses and wildflowers at Chestnut Mountain Ranch.

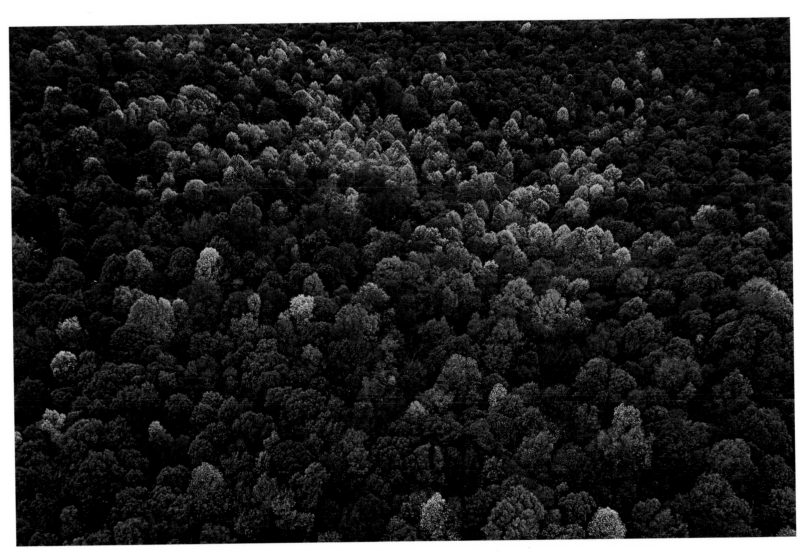

An aerial view of fall colors on Chestnut Mountain, which overlooks Scott's Gulf.

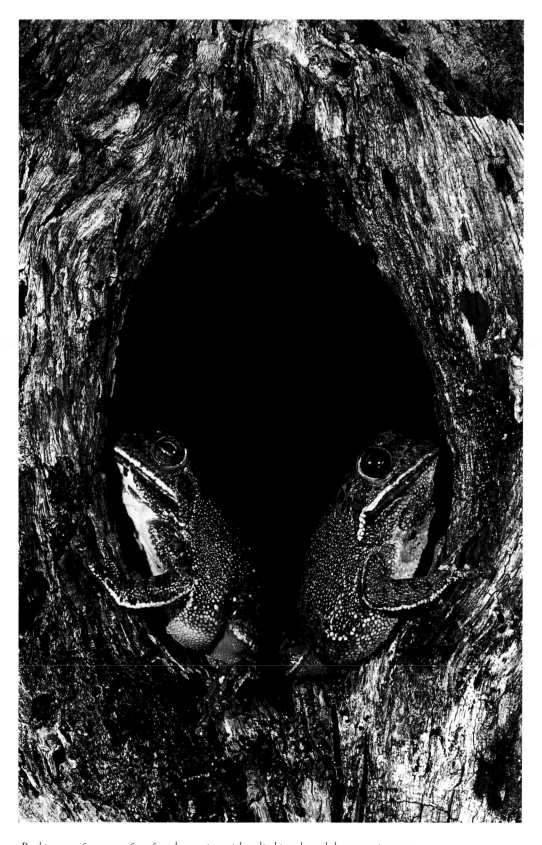

Barking tree frogs are often found on rainy nights climbing through low-growing trees.

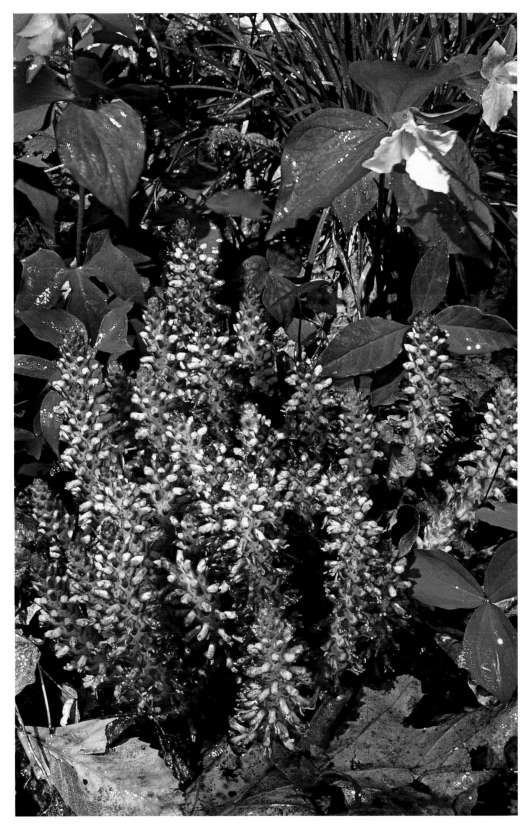

Squawroot, a parasitic plant, grows under the canopies of trees, especially oaks.

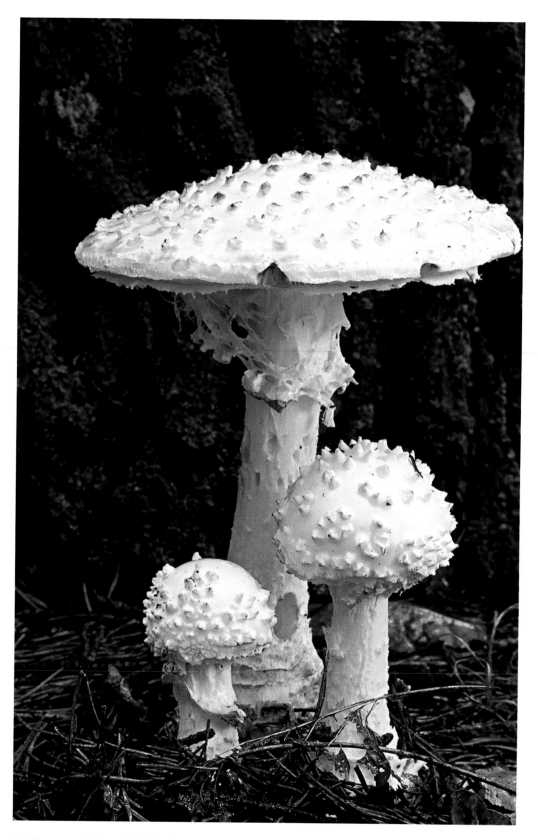

Mushrooms push through the leaf litter after summer rains.

A lone beech holds its leaves through a winter storm.

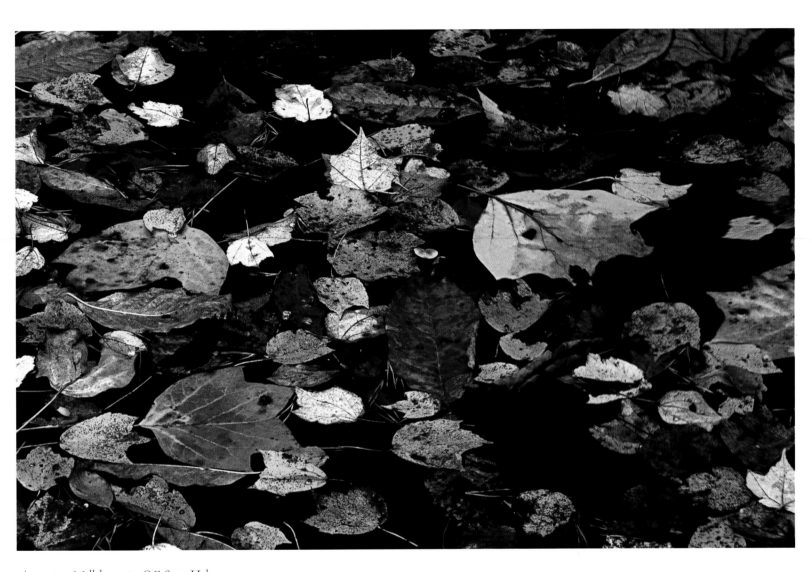

A mosaic of fall leaves in Off Scott Hole.

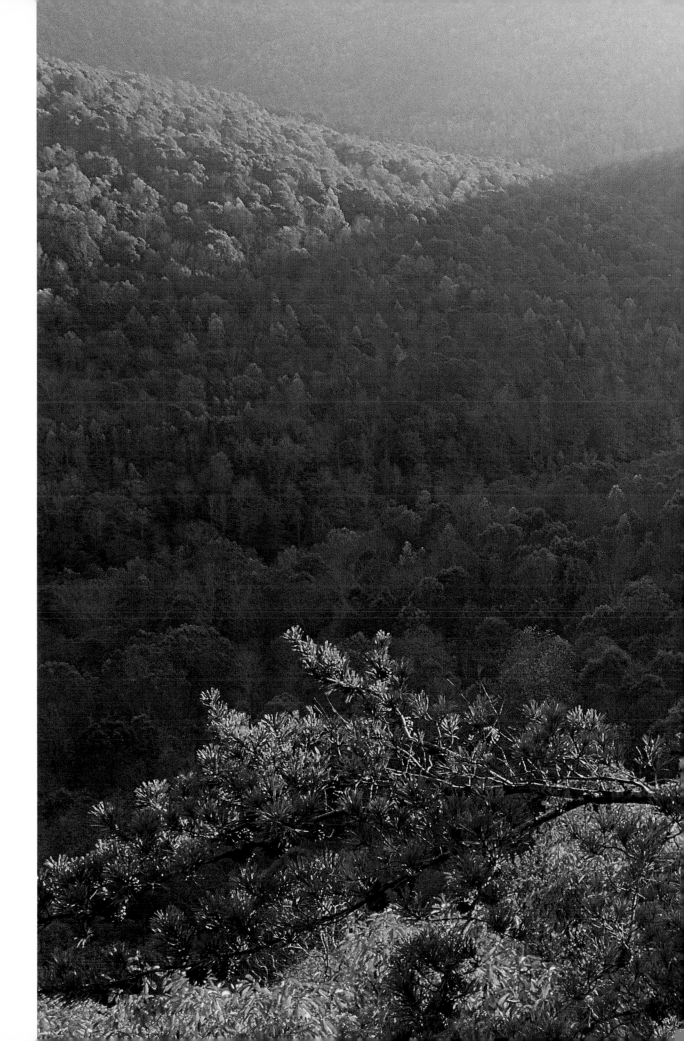

A pristine wilderness, Scott's Gulf provides habitat for wildlife and migrating birds, as well as for a number of rare and endangered species.

32

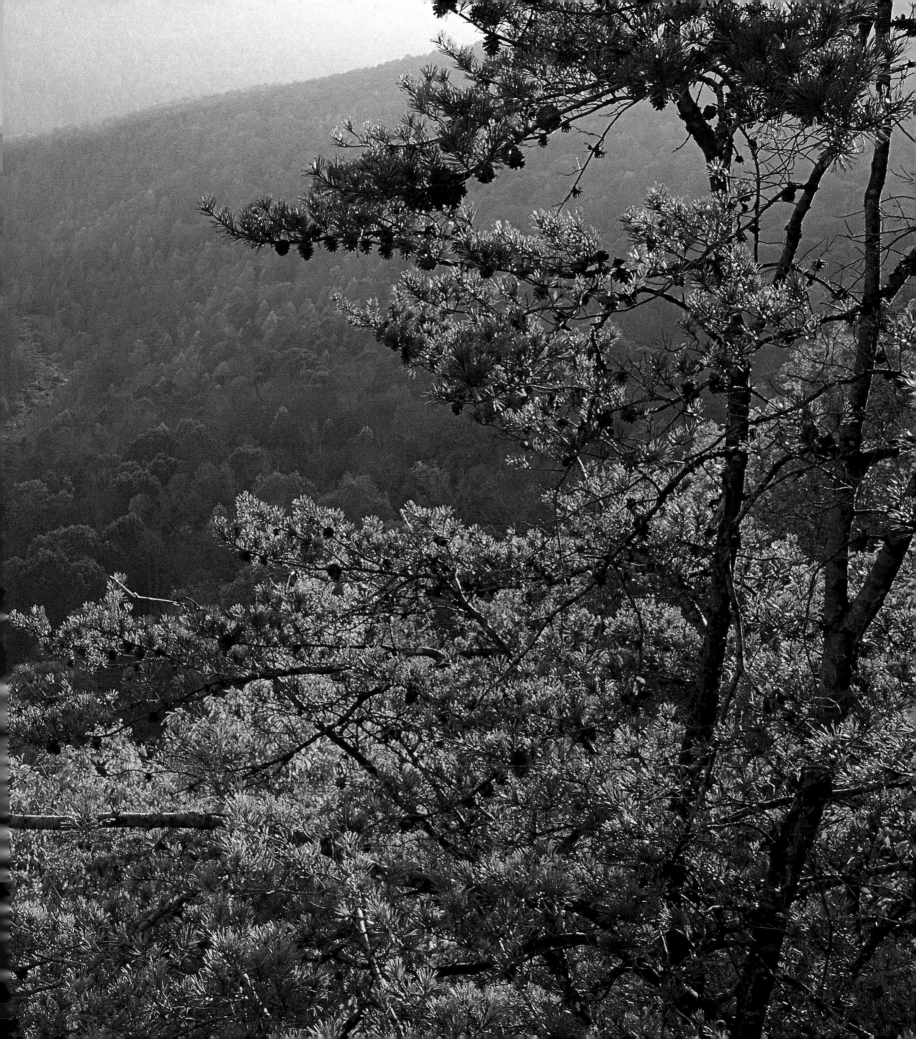

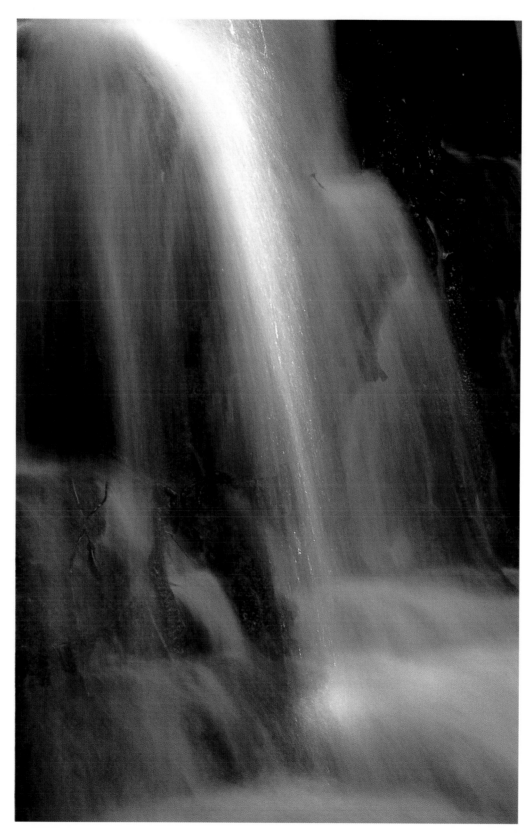

Little-known waterfalls throughout Scott's Gulf have yet to be named.

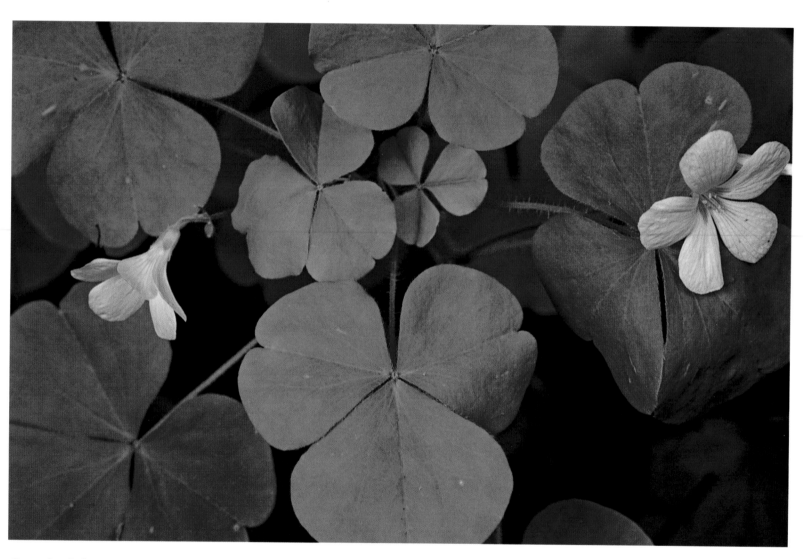

One of hundreds of species of wildflowers found here, yellow wood sorrel carpets the forest floor.

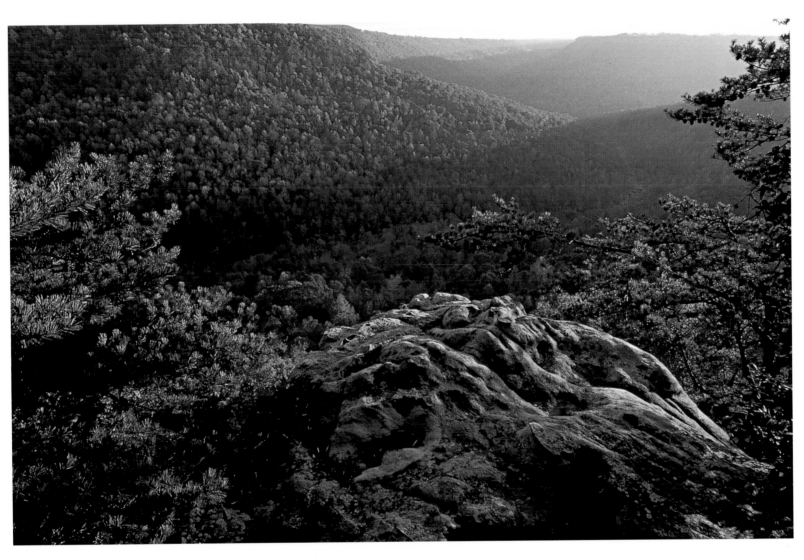

The most spectacular views of the area are from overlooks, such as this vantage from Yellow Bluff.

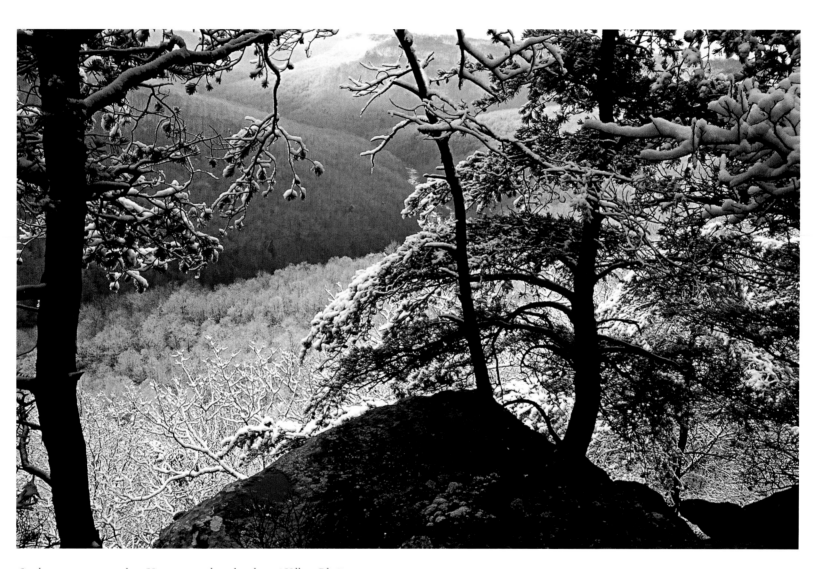

Stark against winter white, Virginia pine line the edges of Yellow Bluff.

Ginseng grows throughout the region and was once dug by locals for export to the Orient.

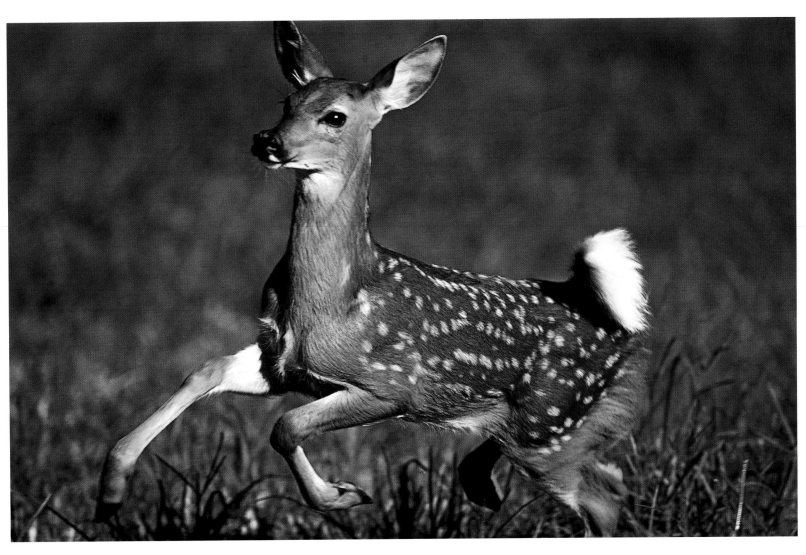

A young fawn heads for the cover of woods along Scott's Gulf, which is managed as a state wilderness area.

LIVING OFF THE LAND

Talk about fishing down in the Gulf...we'd fish at night. Very seldom did we ever fish during the daytime. When I was about seven or eight years old I was scared to death, you know—it was dark down there. Daddy wouldn't let us turn on any lights. I've seen Daddy fish the holes and bring out dishpans full of red-eye.

They used old cane poles, and so he took some guy out there and showed him how to rig up his cane pole and use grasshoppers for bait. They'd throw them out and drag them across the water. And this guy hollered out, "Hey, Archie, I've been fishing an hour and haven't got a bite, what's wrong?" He said, "You checked your bait?" "No, I haven't checked my bait." "You better check it." This old grasshopper got tangled up and it had been sitting on the end of his pole the whole time.

Dry land fish [morel mushrooms] are hard to find but they're good. Chestnut trees were so big people would tie dynamite to the trunk to shake the nuts off the tree. We'd dig up roots and dry them and trade them at the rolling store. The rolling store, he bought herbs, he bought hides. You could trade hogs and chickens. He had crates stacked high with chickens cackling and pigs squealing.

FRANK SMITH

We'd dig star root, star grass, ginseng, mayapple, golden seal. We peeled swamp dogwood. Yellow root was used for sores and stomach ulcers. If you've got a sore on your lip golden seal powder will heal it right up. You know there's a cure for anything out in the woods.

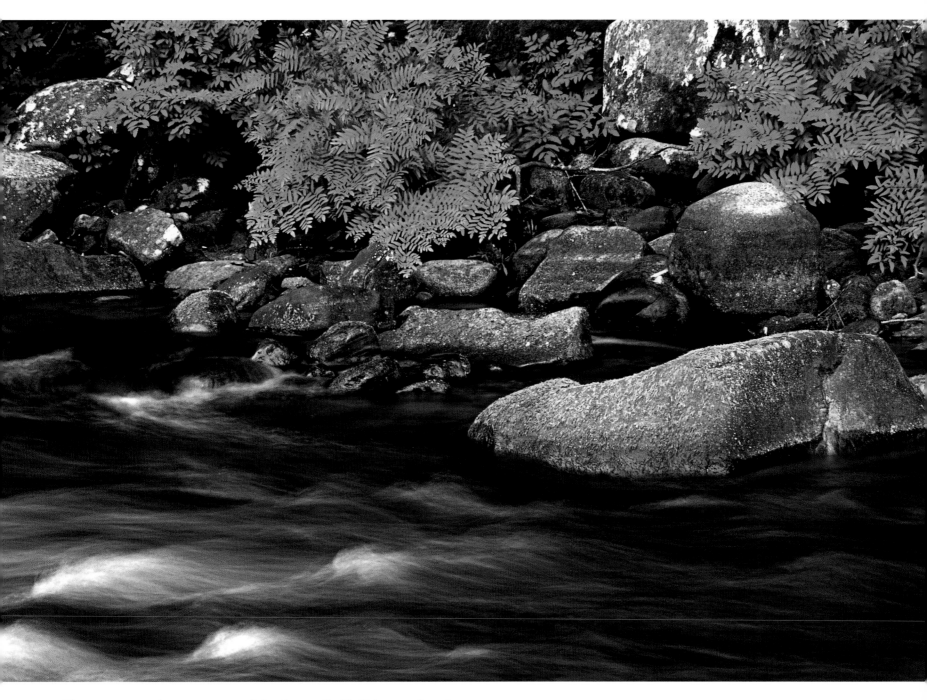

The river runs swiftly over water-smoothed rocks near Shackle Hole, a popular fishing spot.

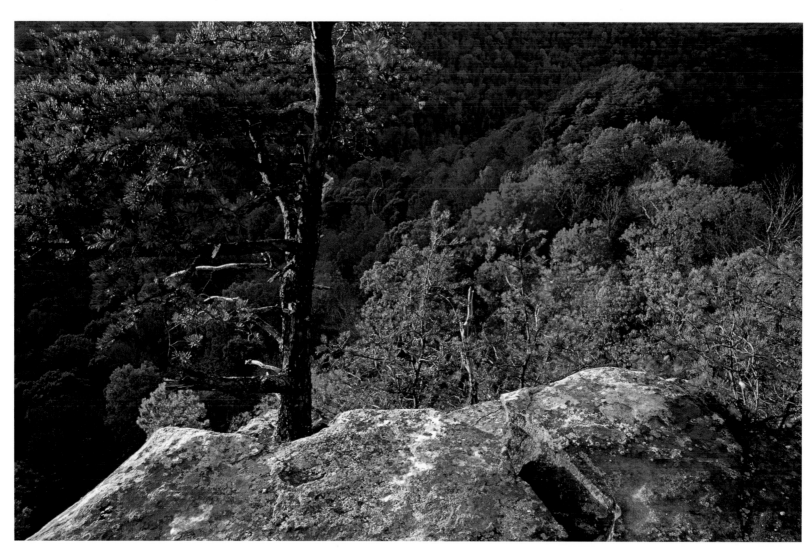

A precipice on Buzzard's Roost is bathed in the warm light of an autumn sunset.

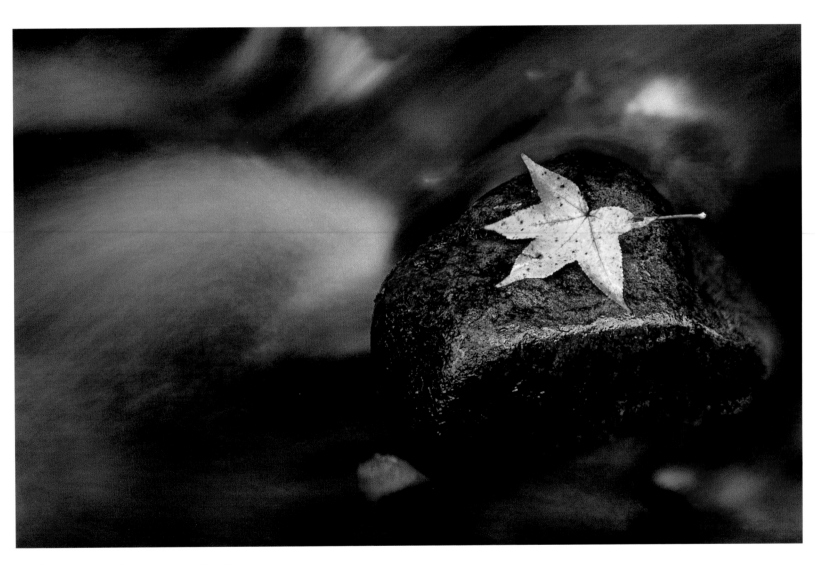

A solitary gum leaf along a section of Bee Creek.

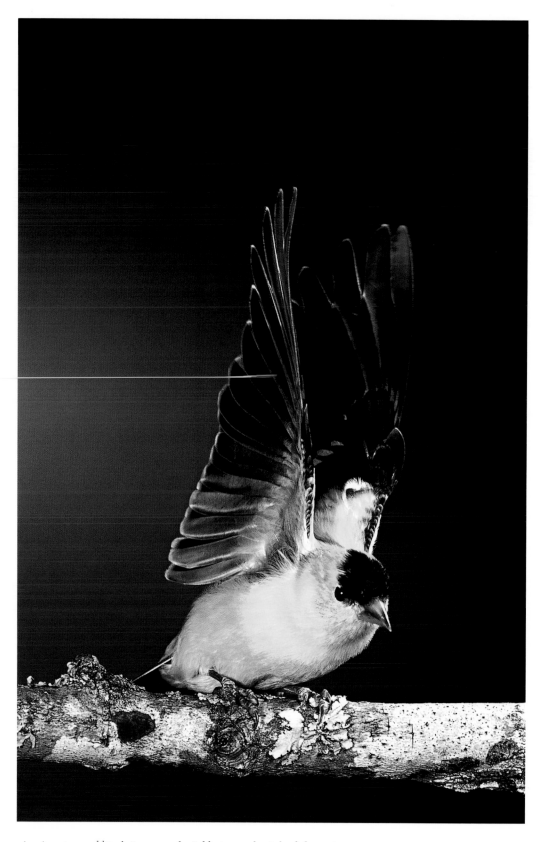

An American goldfinch frequents the fields in search of thistledown for its nest.

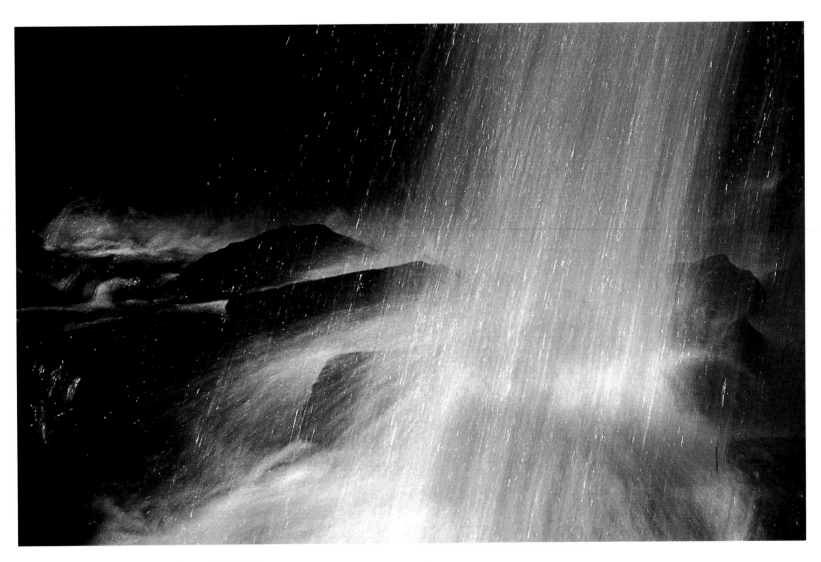

Waterfalls are found throughout the Cumberland Plateau.

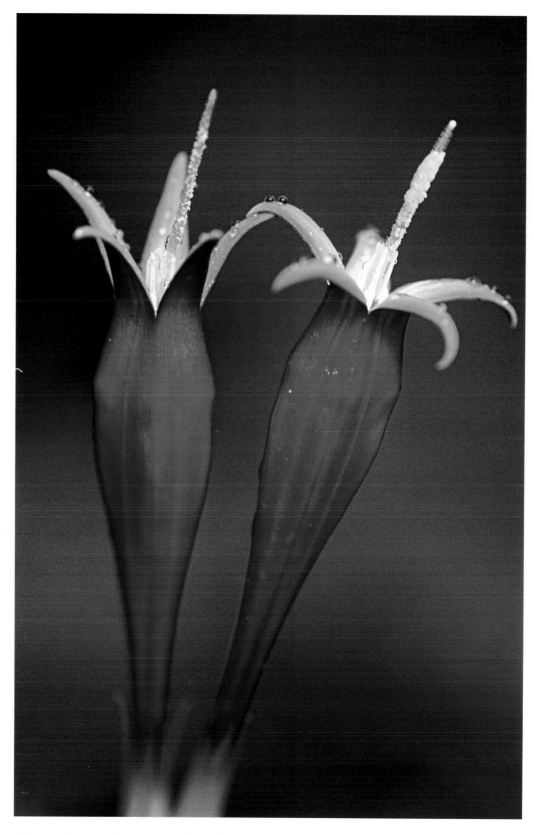

Indian pink grows along the riverbanks of the Caney Fork.

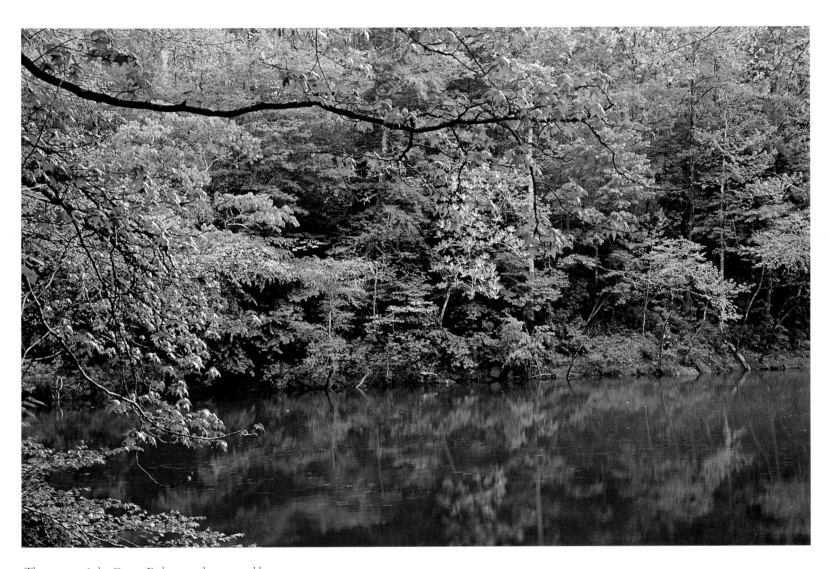

The waters of the Caney Fork are a clear, emerald green.

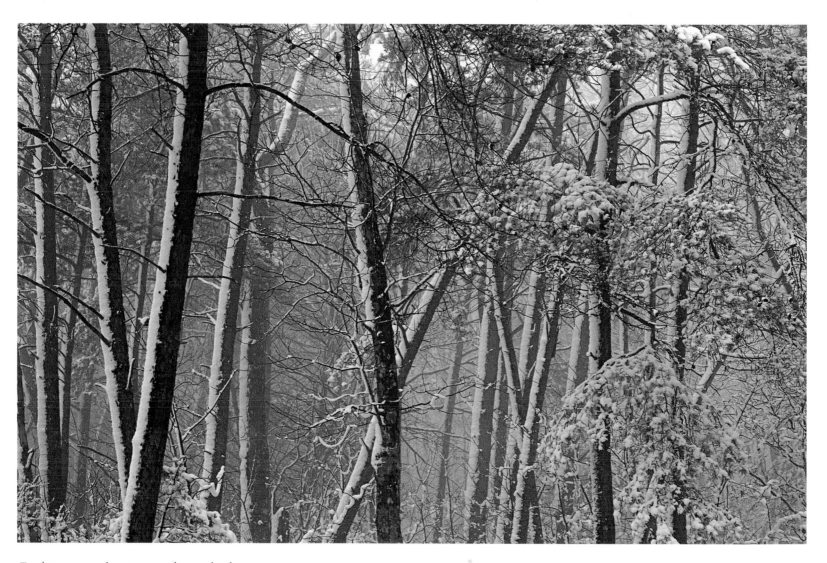

Fog drifts among the winter woods atop the plateau.

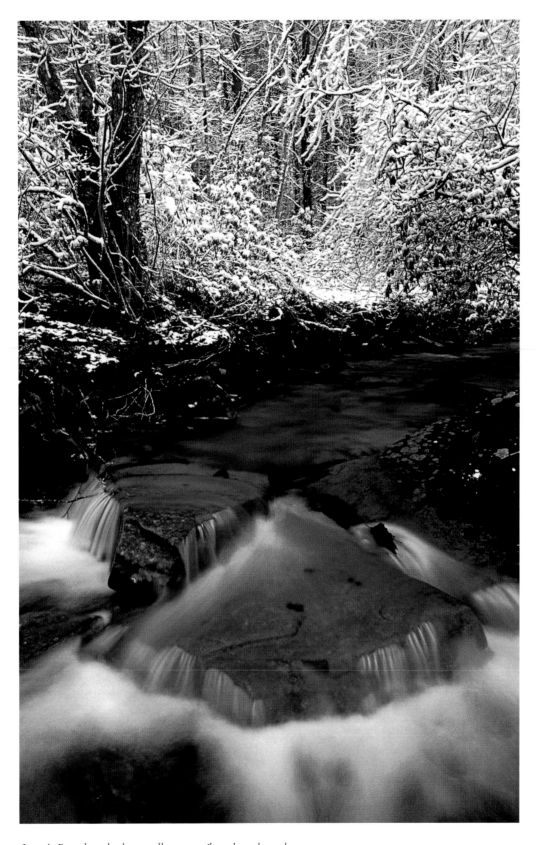

Jenny's Branch and other small streams flow throughout the year.

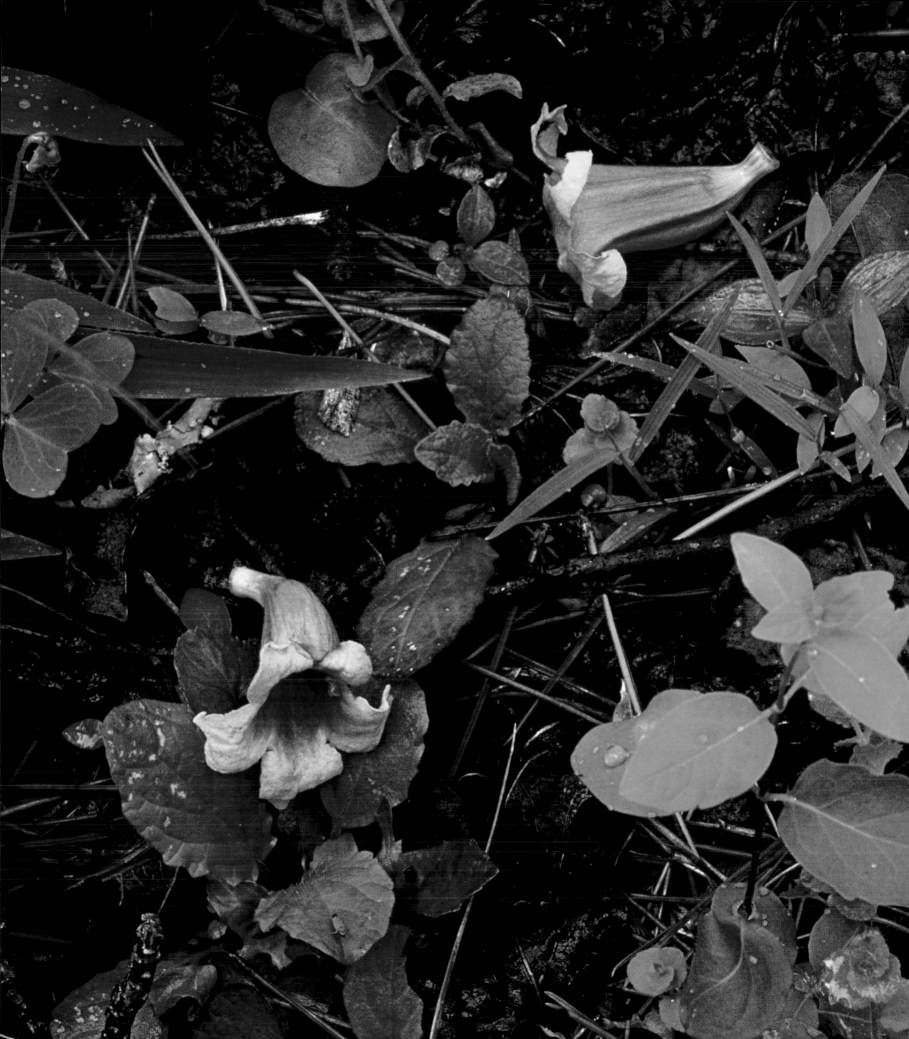

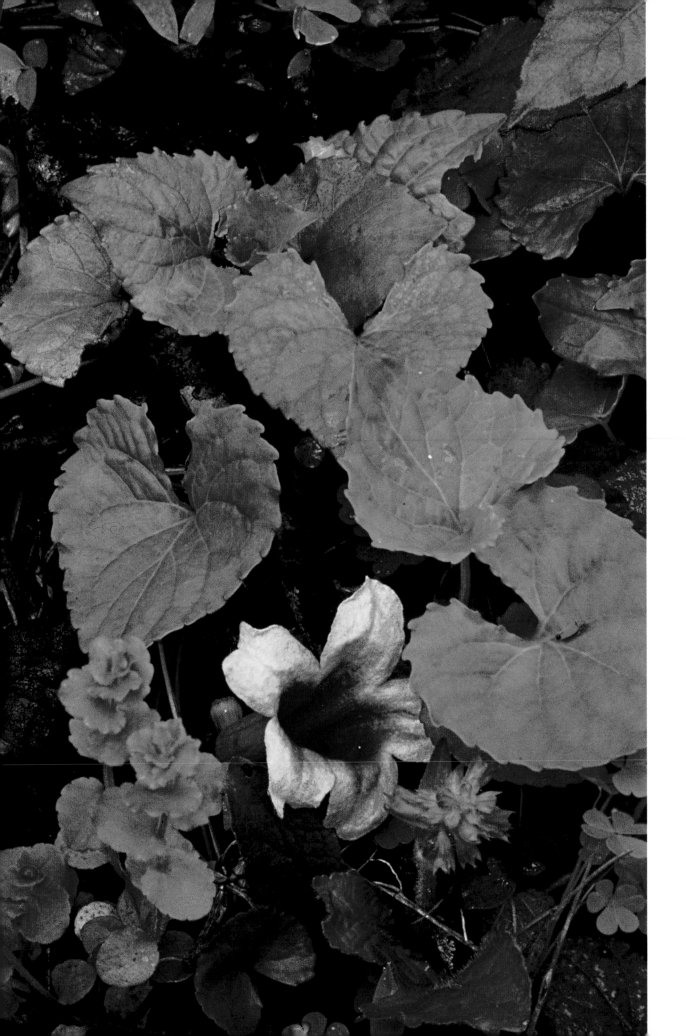

The golden trumpets of crossvine burnish the forest floor.

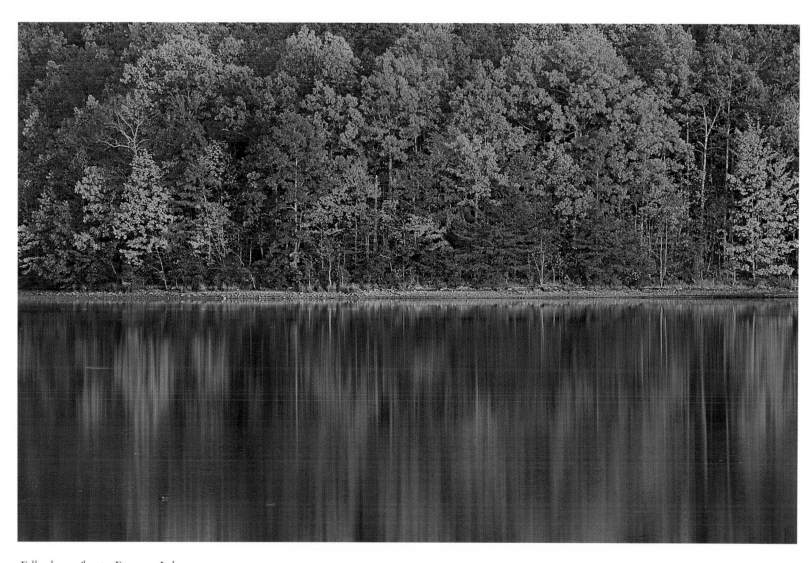

Fall colors reflect in Firestone Lake.

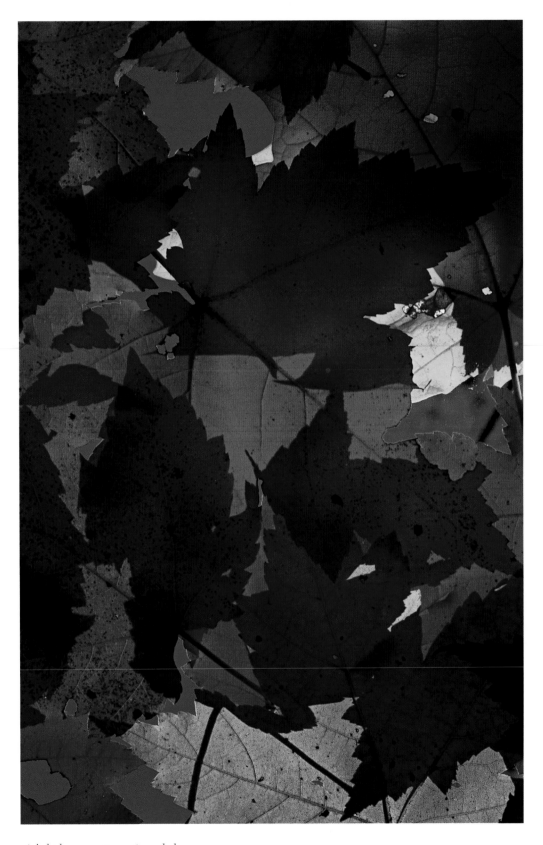

A kaleidoscope pattern of maple leaves.

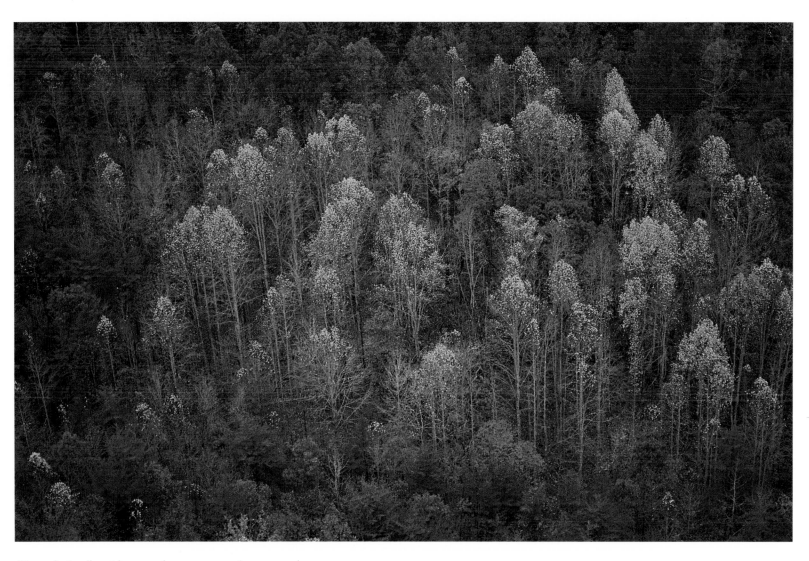

The poplar's yellow foliage stands out against rich autumn colors.

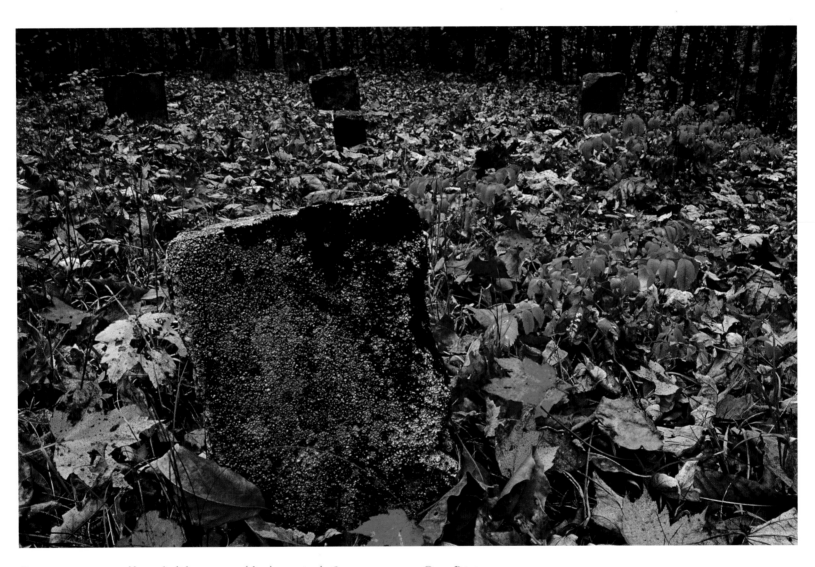

Few names remain visible on the lichen-encrusted headstones in the Scott cemetery atop Cager Point.

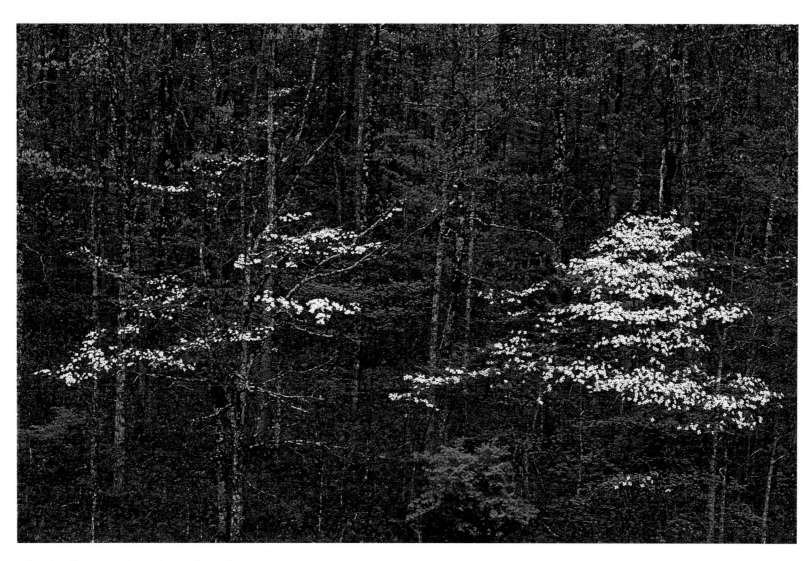

The white blossoms of dogwood trees filigree the forest in spring.

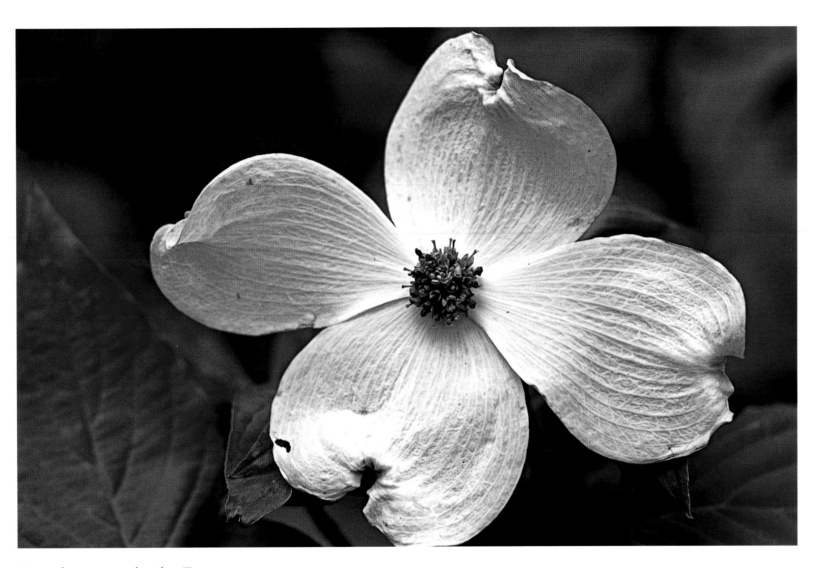

Dogwoods are common throughout Tennessee.

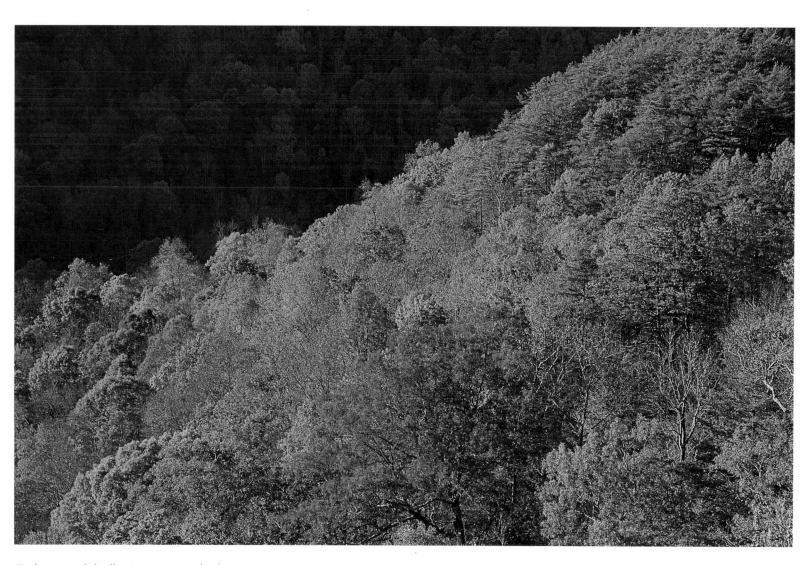

Early evening light illuminates a forested ridge.

Autumn color along Wilson's Ridge.

A Hunting Life

Back when I was a boy, me and my cousin would coon hunt, possum hunt and skunk hunt. It didn't make any difference what it was out there—when we caught it, we skinned it. We would dress them, carry them out and sell them. I know one Christmas we sold our catch for twenty-two dollars and that's the most money we ever saw back then. We split the money and bought more shells.

Times were hard. It was during the Depression; money was a scarce item, so you would eat just about anything. Coon, my grandmother could fix a coon—baked it with sweet potatoes and black pepper on that thing. It was good eating. One time she cooked some possum and I ate it but I didn't eat it with a good stomach. We ate groundhogs, squirrels and rabbits. Deer and turkey had all been killed out of the Gulf. I only heard of one man eating a skunk.

Bill and Glenda's grandfather and another man were camping on top of the Gulf one winter and they caught a skunk. They were rendering the grease out of it to put on their guns and the man said, "that's the best smelling thing I've ever smelled, let's take a taste of it." He said it tasted good. I guess old people could cook anything and make it taste good.

We hunted with a couple of dogs, mostly at night. We would go to school in the morning and they couldn't hardly stand the scent of us because of us catching skunks. We didn't trap too much, but we would set a steel trap for rabbits every night. Frank, he was just a little boy then, he would check it in the morning. One morning he went down to the trap and bent down to look and a skunk sprayed him right in the face and Frank took off running. It burned his eyes.

Joseph "Dude" Smith

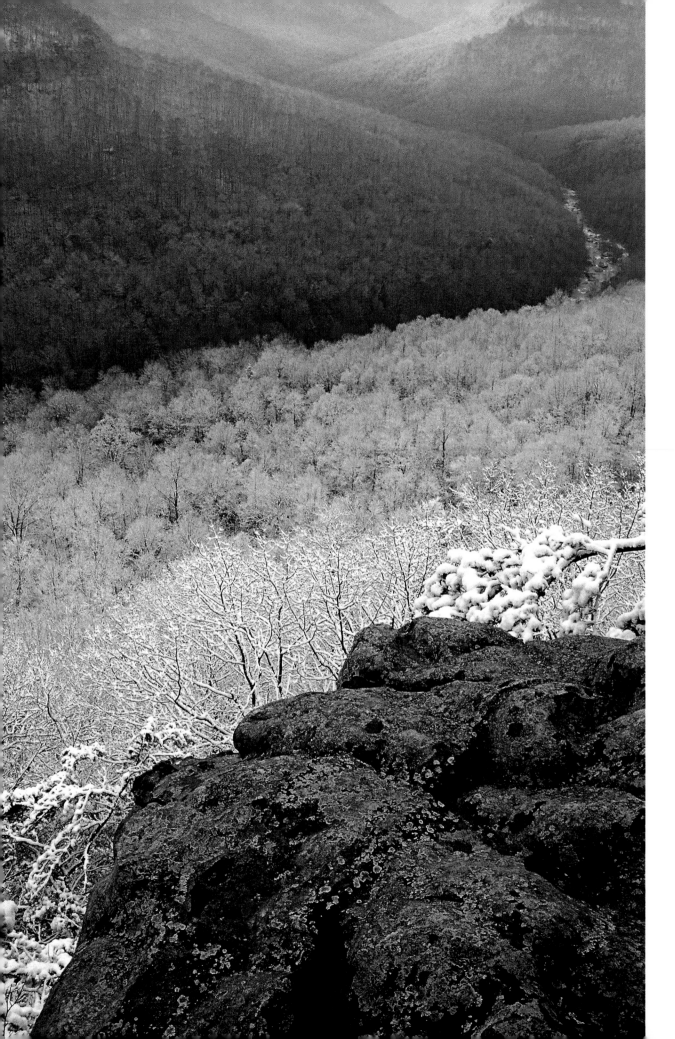

Families of Scotch and Irish descent first settled Scott's Gulf in the late 1700s.

61

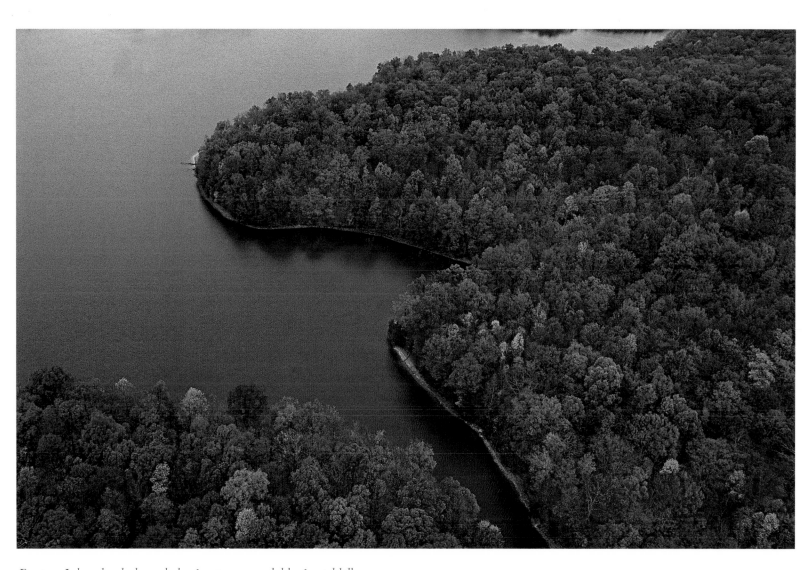

Firestone Lake, a hundred-acre body of water surrounded by forested hills.

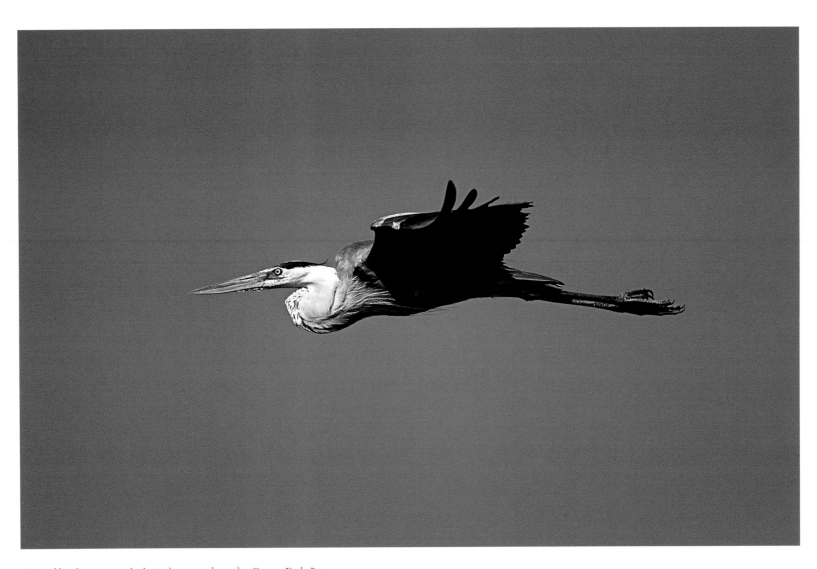

Great blue herons nest high in the trees along the Caney Fork River.

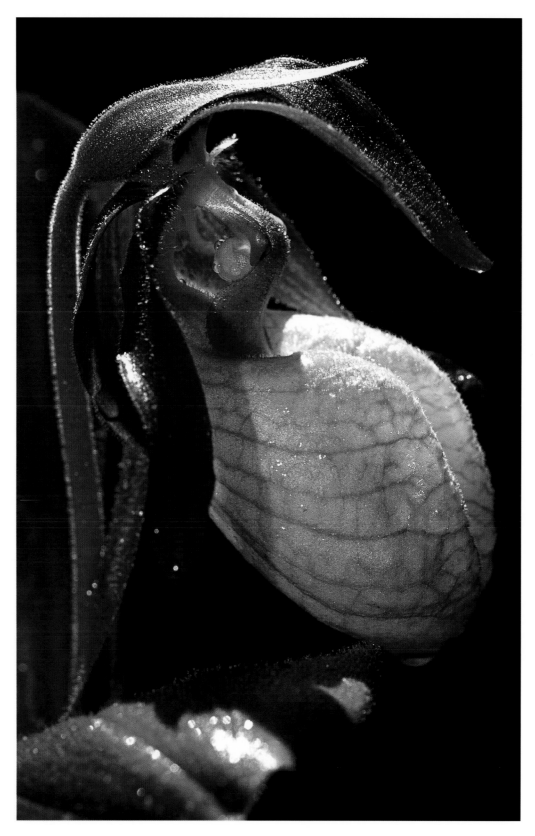

A pink lady's slipper, one of several kinds of orchids that grow here.

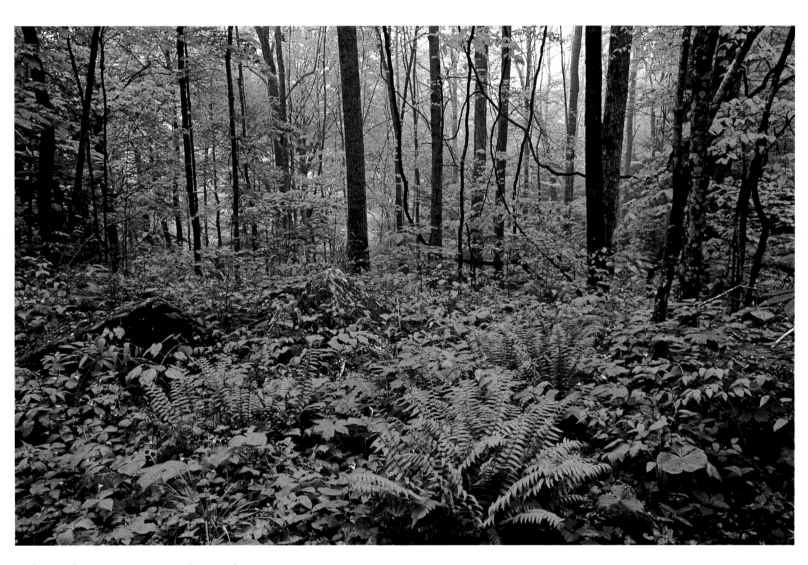

A dense understory of ferns carpets the forest floor.

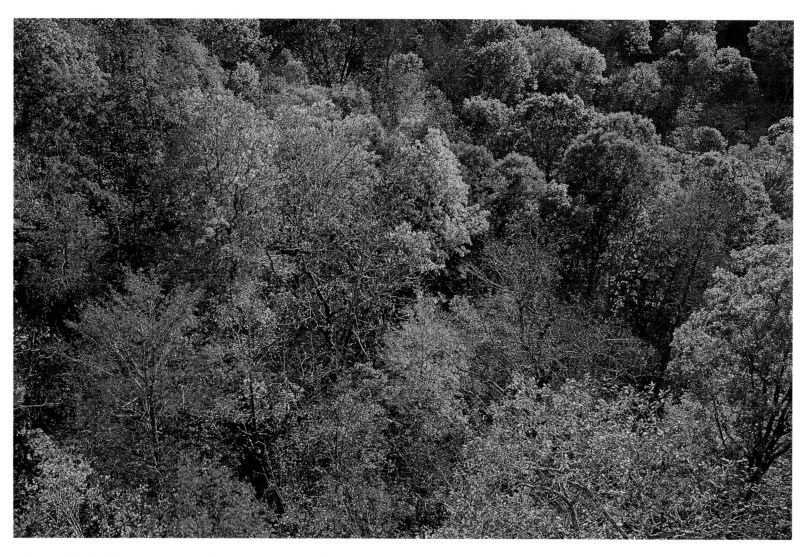

The mixed hardwood forests of Scott's Gulf are some of the most diverse in the world.

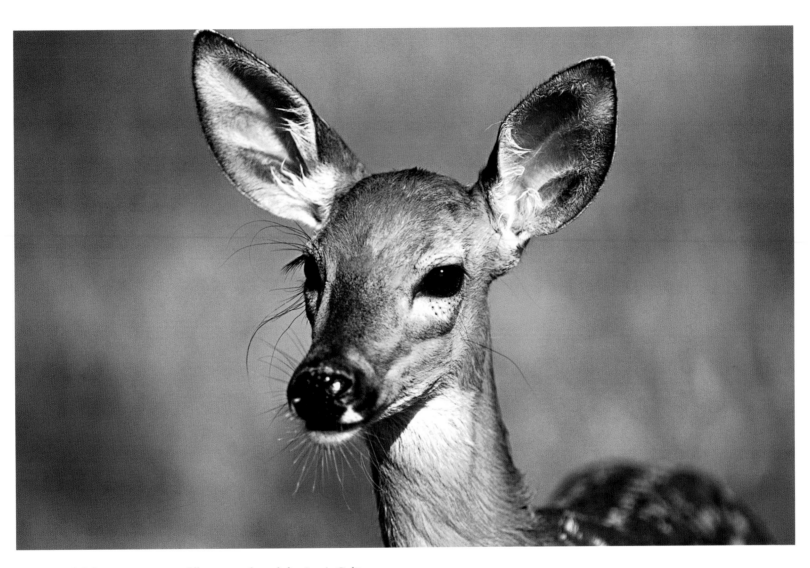

A white-tailed deer, one of many wildlife species that inhabit Scott's Gulf.

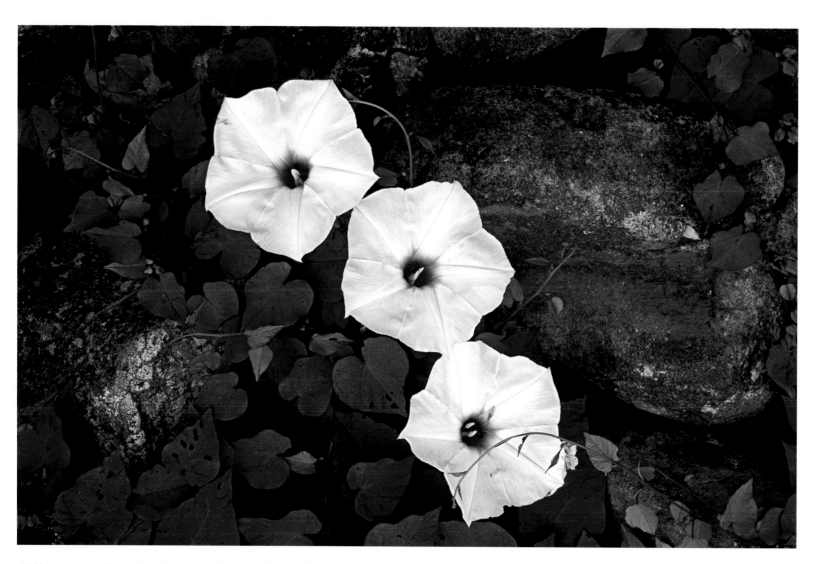

Wild potato vines bloom along the riverbanks of the Caney Fork.

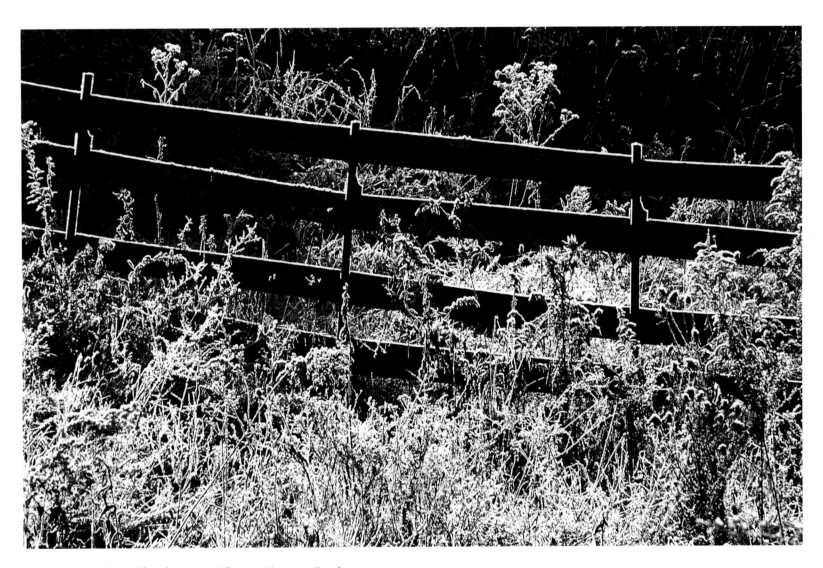

Frosted grasses and an old cattle fence on Chestnut Mountain Ranch.

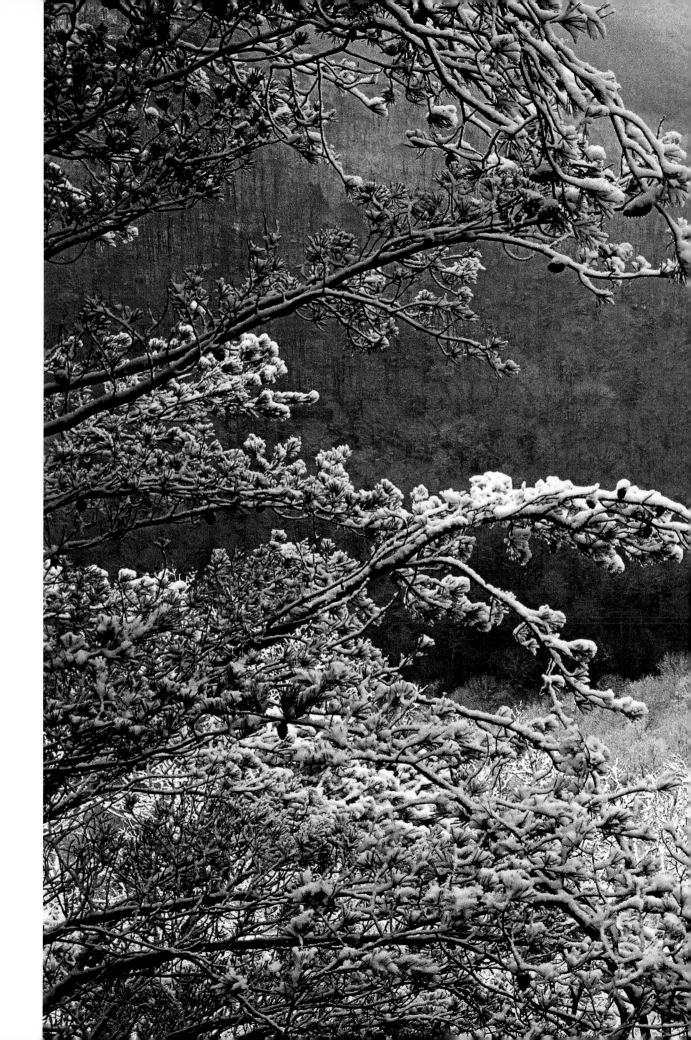

Winter gently blankets the forest and the gorge below, as seen from Yellow Bluff.

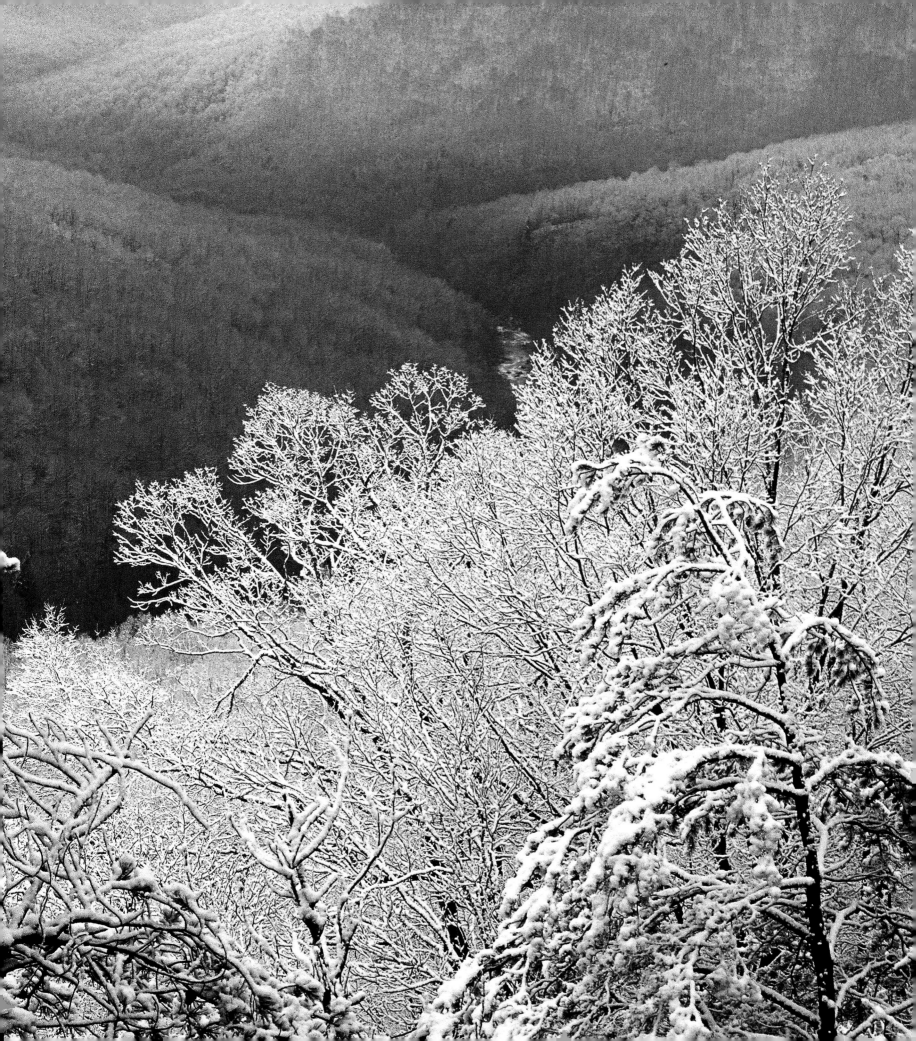

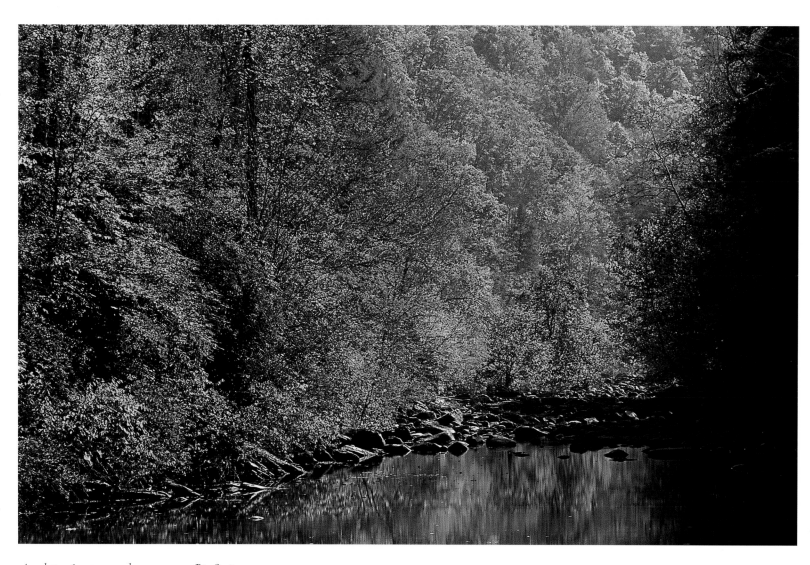

A palette of autumn colors seen near Big Springs.

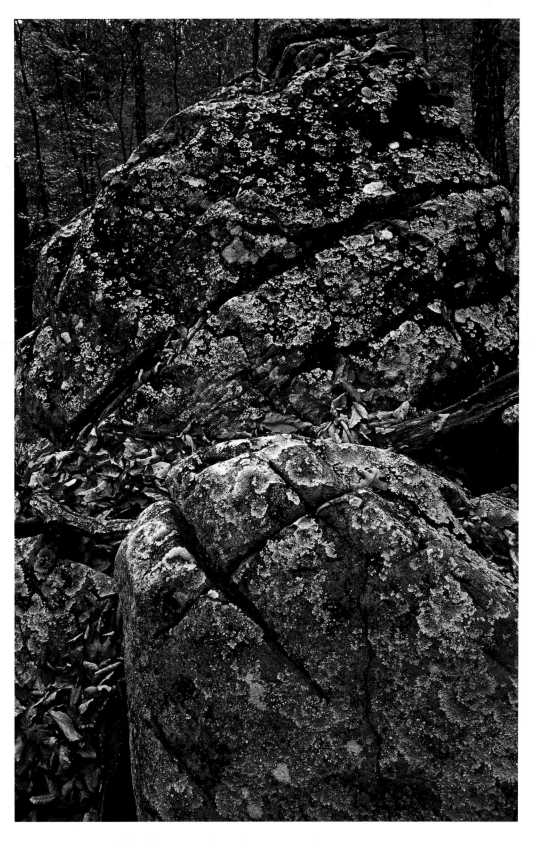

Massive, lichen-covered boulders are found throughout Scott's Gulf.

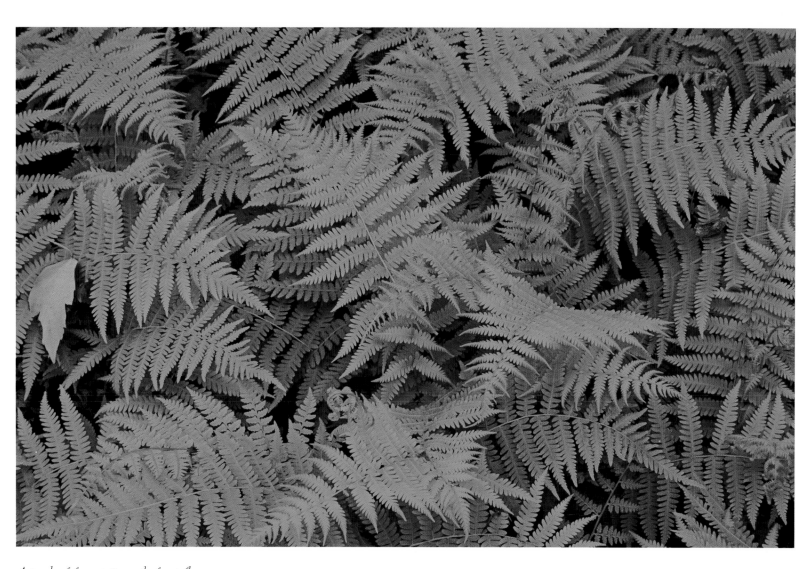

A tangle of ferns patterns the forest floor.

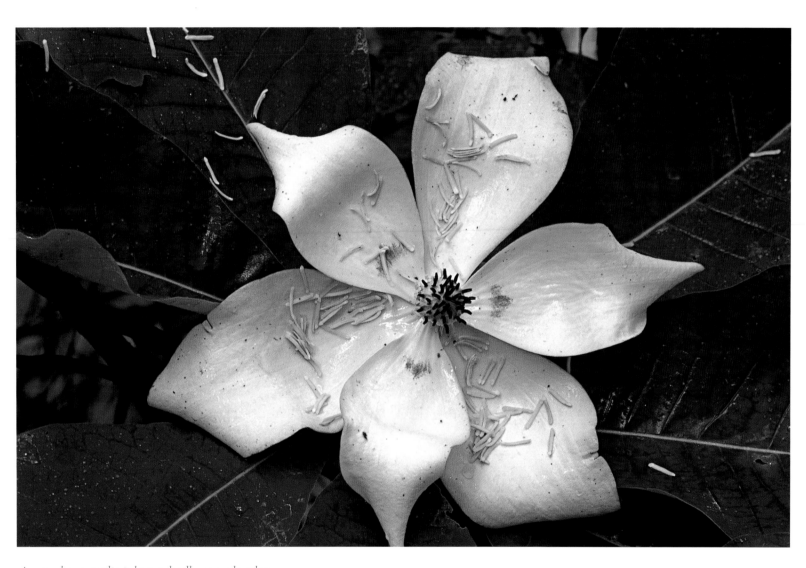

A cucumber magnolia is known locally as a calcumber.

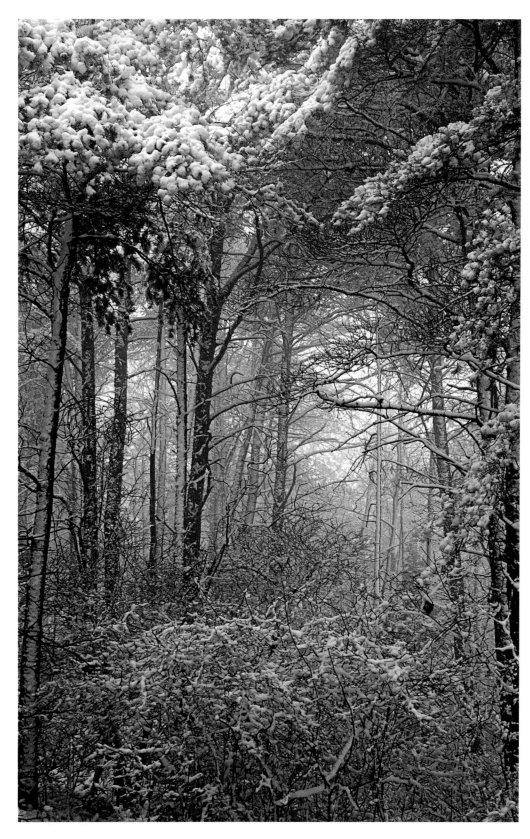

A foggy, snow-hushed forest atop the plateau.

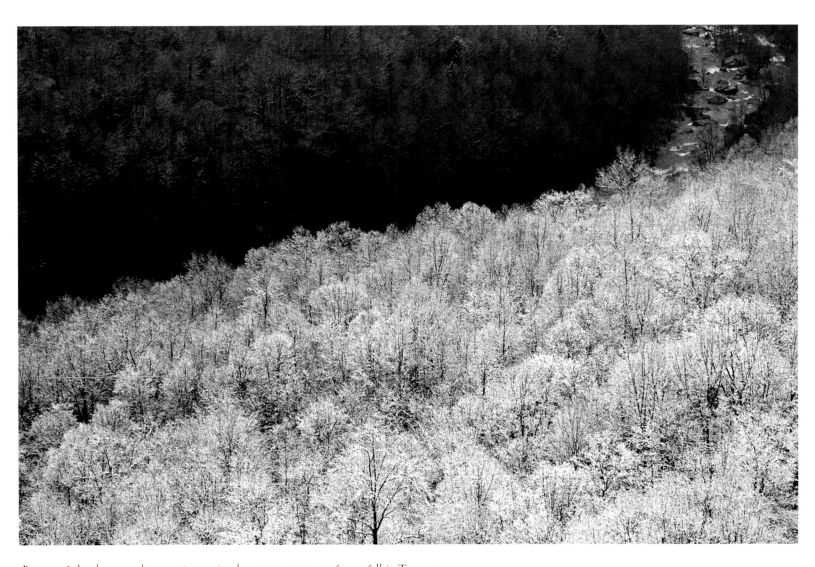

Regions of the plateau and mountains receive the greatest amounts of snowfall in Tennessee.

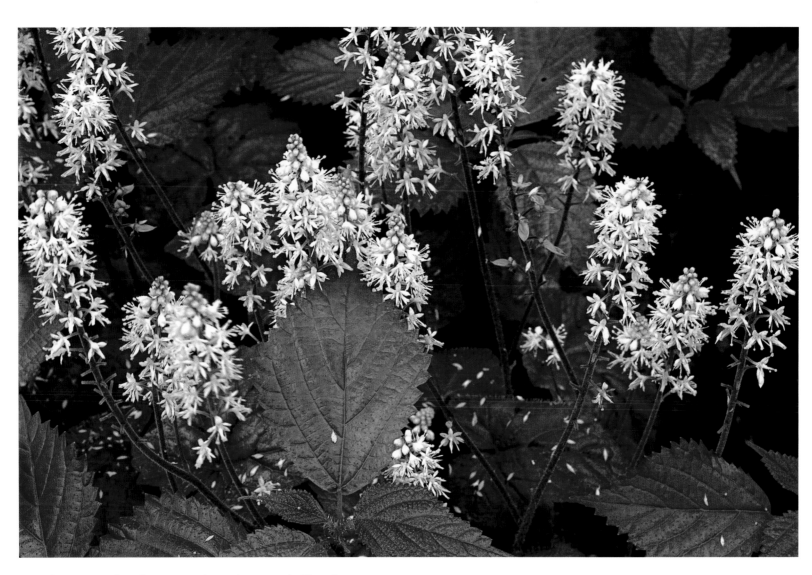

Foamflowers grow along the Caney Fork, seen here near Shackle Hole.

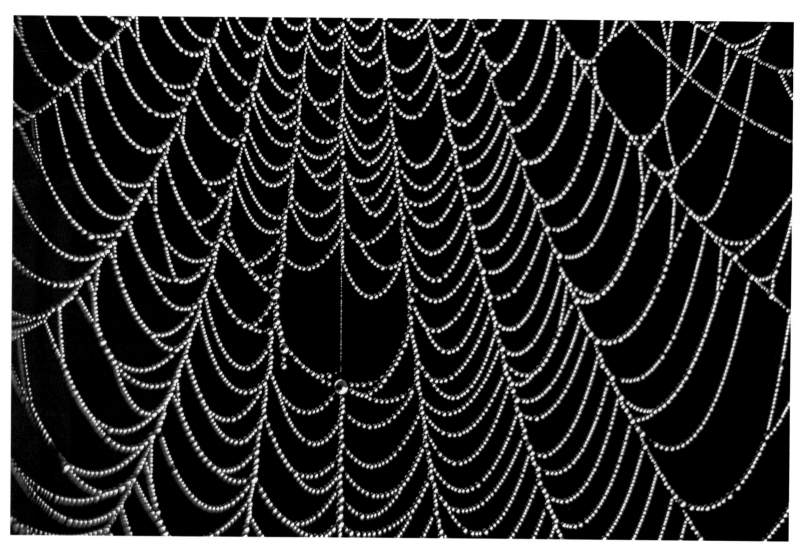

Strands of a spiderweb draped with dewdrops.

SCOTT'S GULF MEMORIES

Families were big in the Gulf. Frank and Dude come from a family of eight and I come from a family of thirteen. If you were the youngest of thirteen you had to learn to eat fast. Back then about everybody hunted, squirrel mostly. My brothers would go out and shoot squirrels while my mom and sisters picked blackberries and huckleberries. The state let deer loose in the sixties but there was more squirrel hunting in the Gulf than anything. In the late seventies and early eighties we helped them release turkey in the area too.

I started going down into the Gulf in the late fifties. Back then you could drive a car in. Before I was old enough to drive a car my folks let me drive an old tractor in and out of the place. I guess the people that owned the saw mill kept up the road. There was an old mill about a hundred feet long with picnic tables nearby.

The best fishing trip we were ever on was without a fishing pole. We were in water about knee-deep and we reached under the rocks and just pulled the fish right out. We caught so many you couldn't hold the stringer out straight. I never was much of a grasshopper fisherman. I liked crawfish and spring lizards.

One time when I was a teenager, we were fishing and I heard my first wildcat. Way down the river you could hear him squawling. We were cleaning our fish and left the scraps and the next morning they were gone. I haven't heard any bobcats in years. But way back in one of the caves we found a perfect bear claw print in red clay. It was way back, about forty-five minutes in the cave.

BILL BRYANT

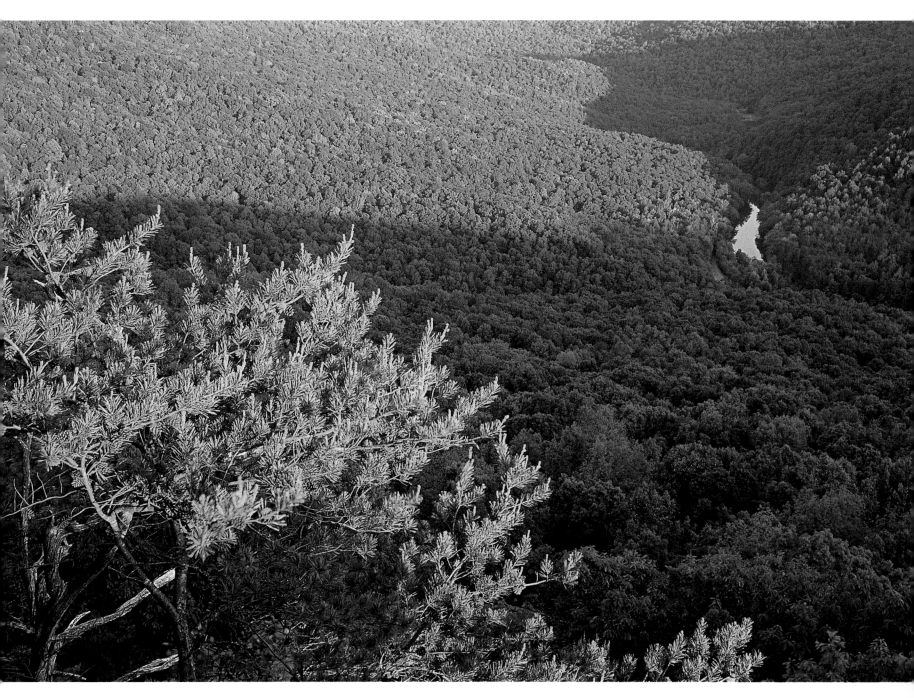

Hunting and fishing are a traditional way of life in Scott's Gulf.

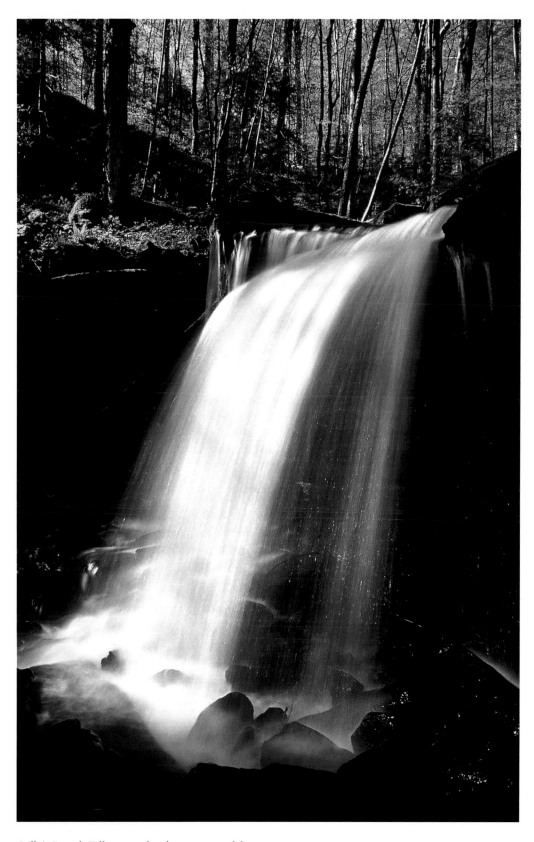

Polly's Branch Falls, a popular destination for hikers.

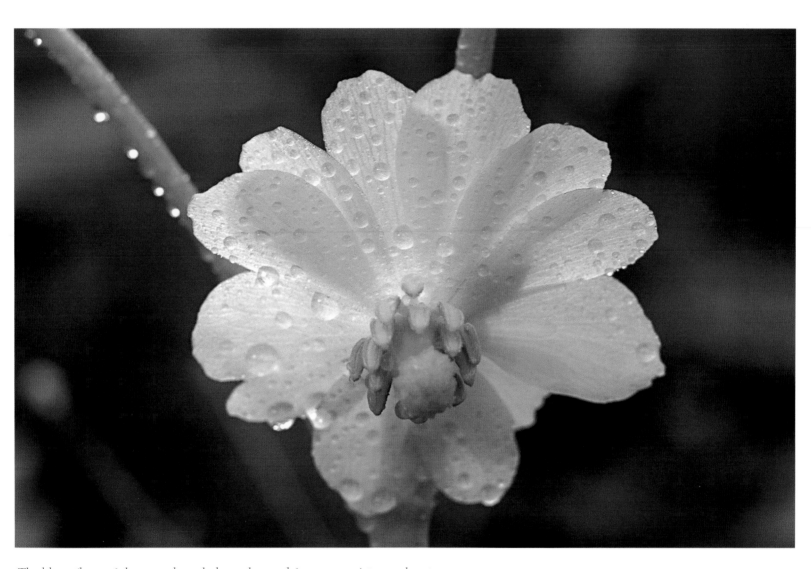

The delicate flower of the mayapple, an herb once harvested for export to Asian apothecaries.

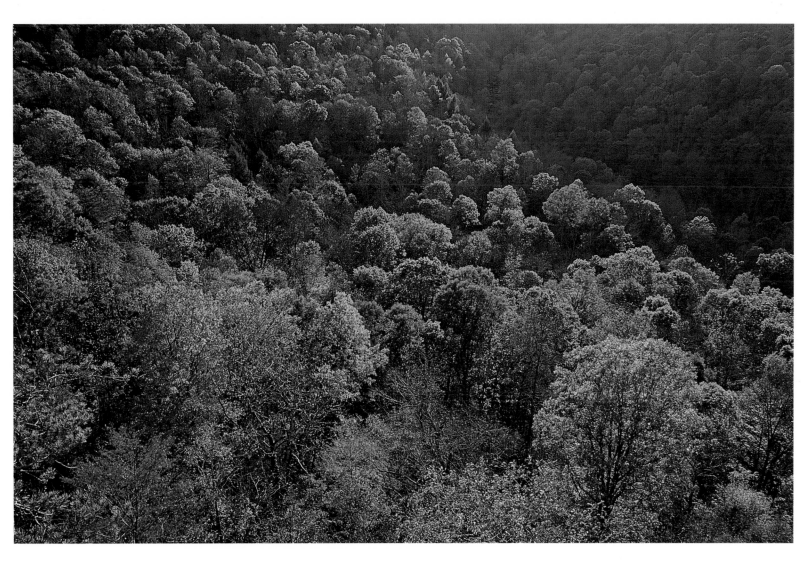

The forests of Scott's Gulf offer a quiet nature experience for visitors to this remote region.

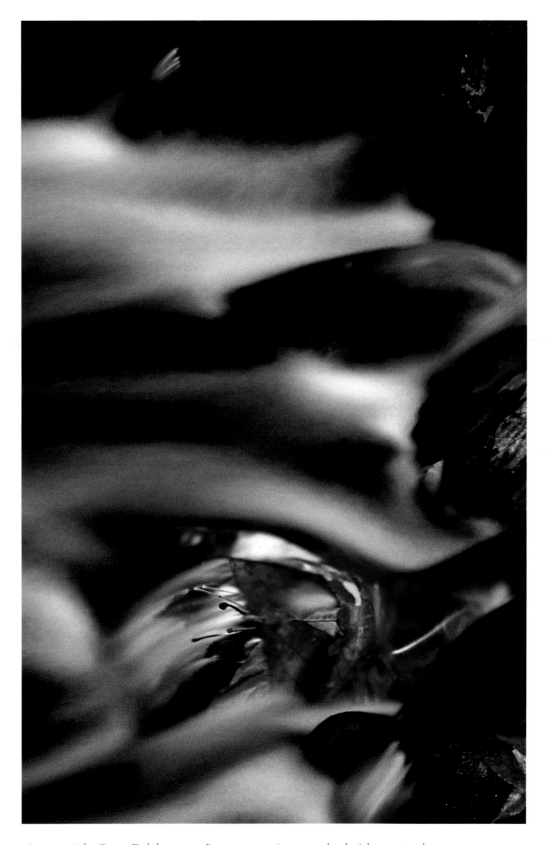

An area of the Caney Fork known as Ripsnort, one of many such colorful names in the region.

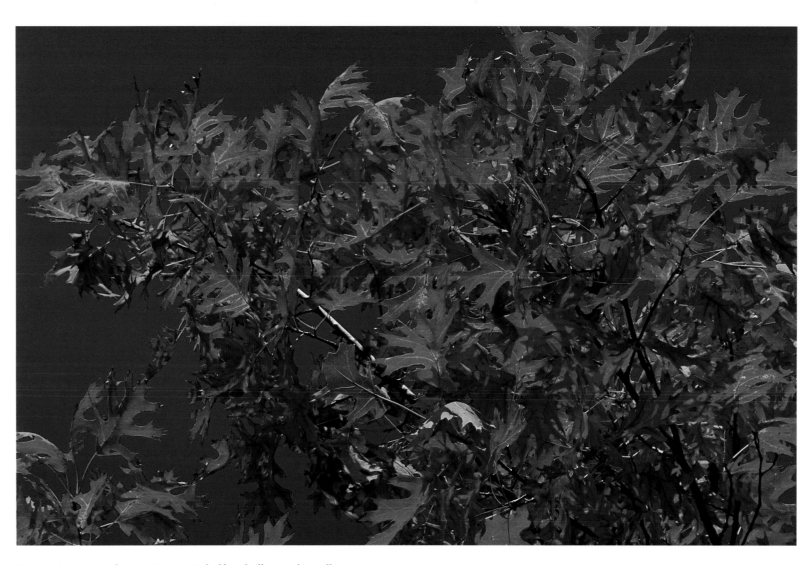

Leaves of a water oak near Firestone Lake blaze brilliant red in fall.

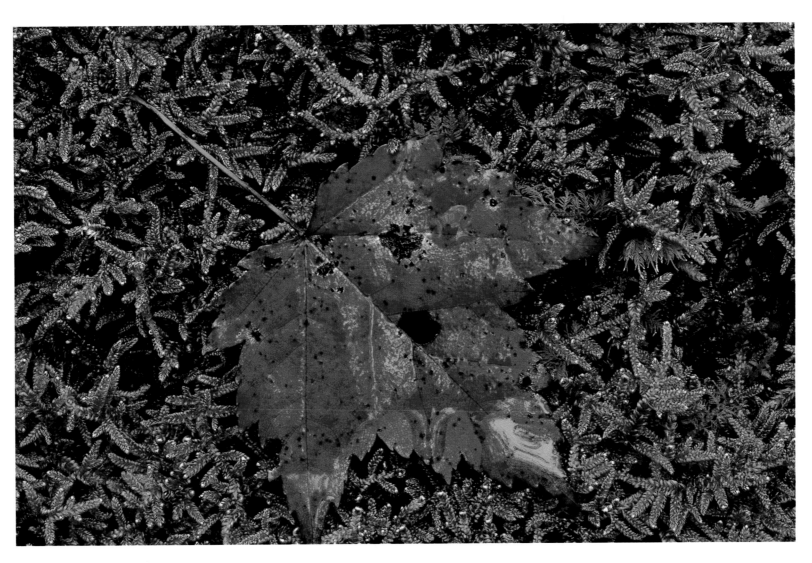

A single maple leaf adorns the forest floor.

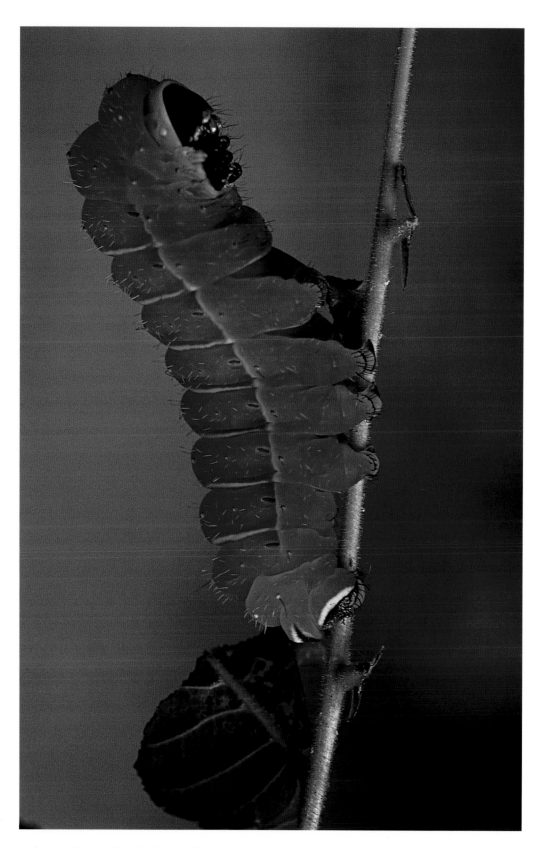

A luna moth caterpillar blends in with its green environment.

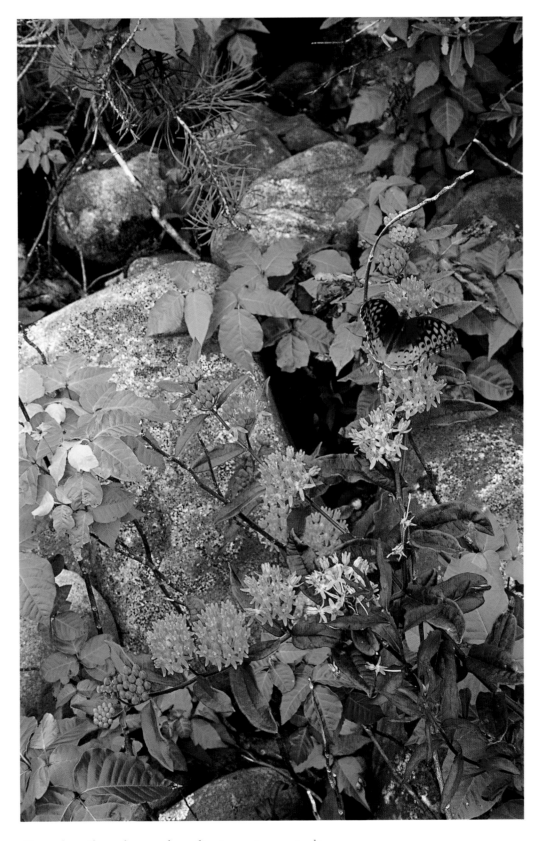

Orange butterfly weed attracts butterflies, just as its name implies.

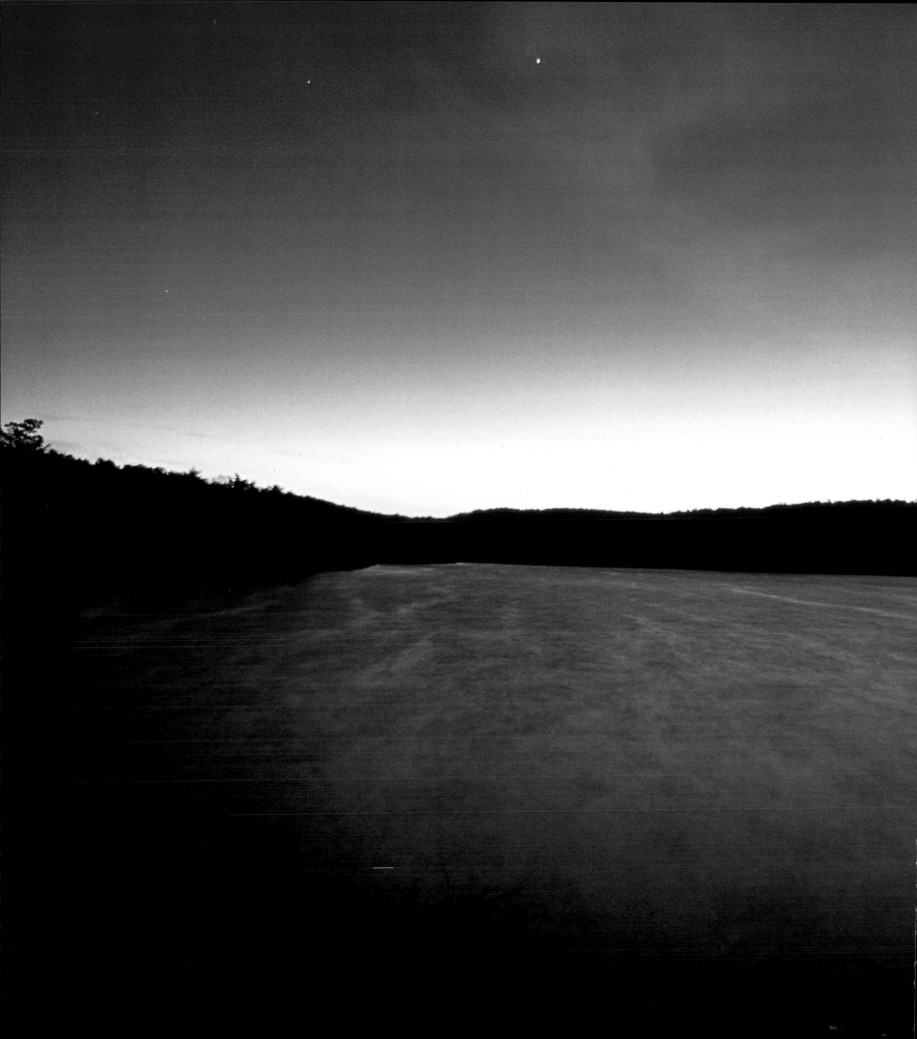

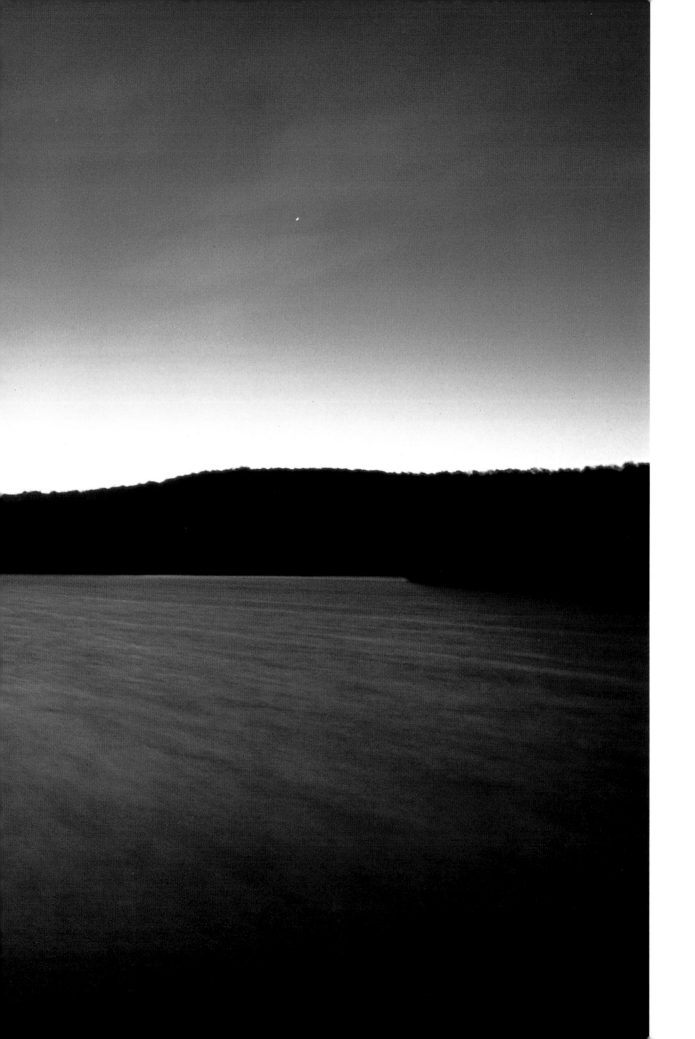

Predawn over Firestone Lake, which is a source of water for surrounding communities.

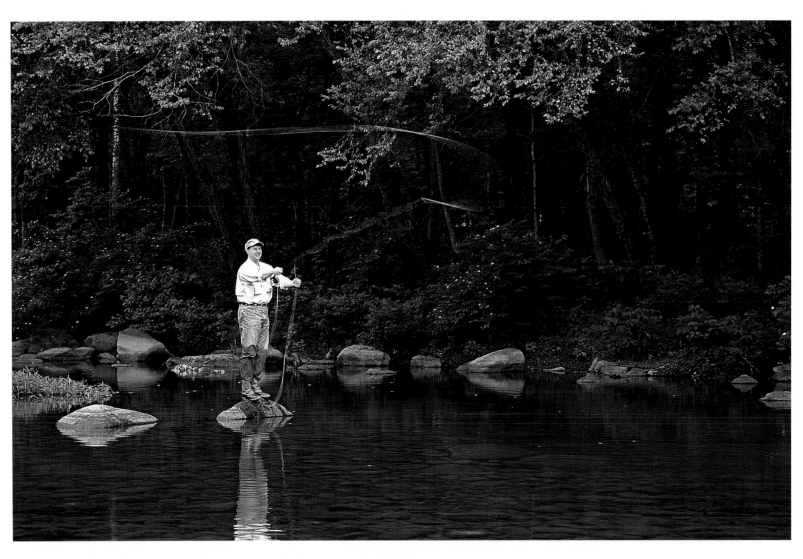

From atop a rock, a fisherman can see fish swimming in the clear water at Shackle Hole.

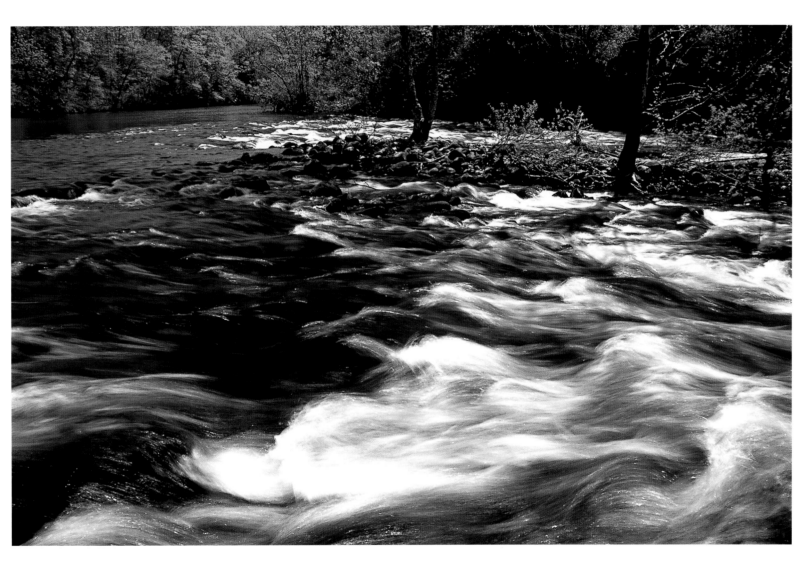

During spring high water, portions of the Caney Fork can swell to Class V white-water rapids.

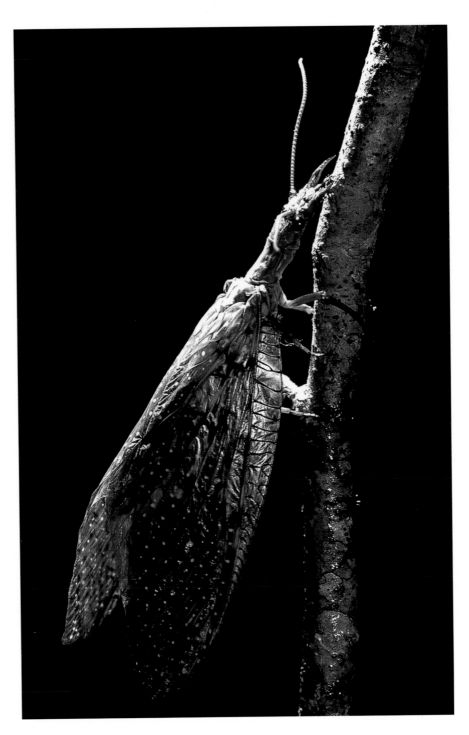

A hellgrammite crawls up a twig.

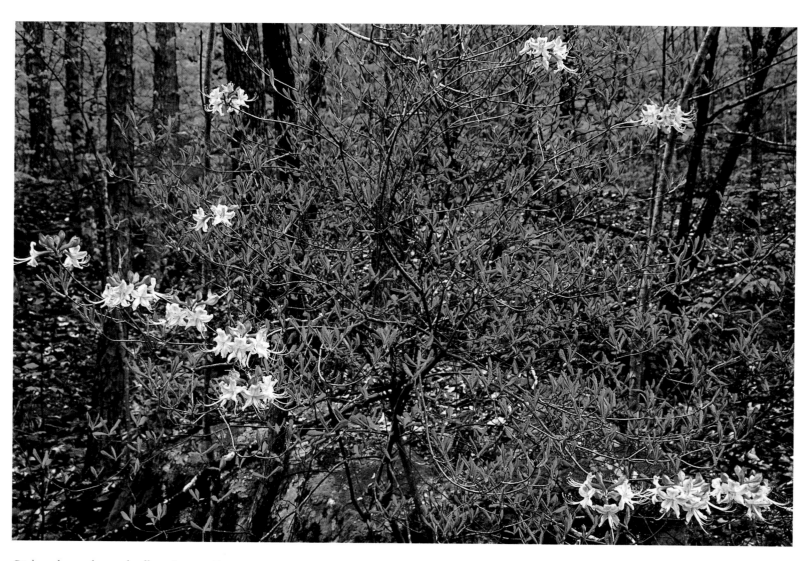

Pink azalea are known locally as honeysuckle.

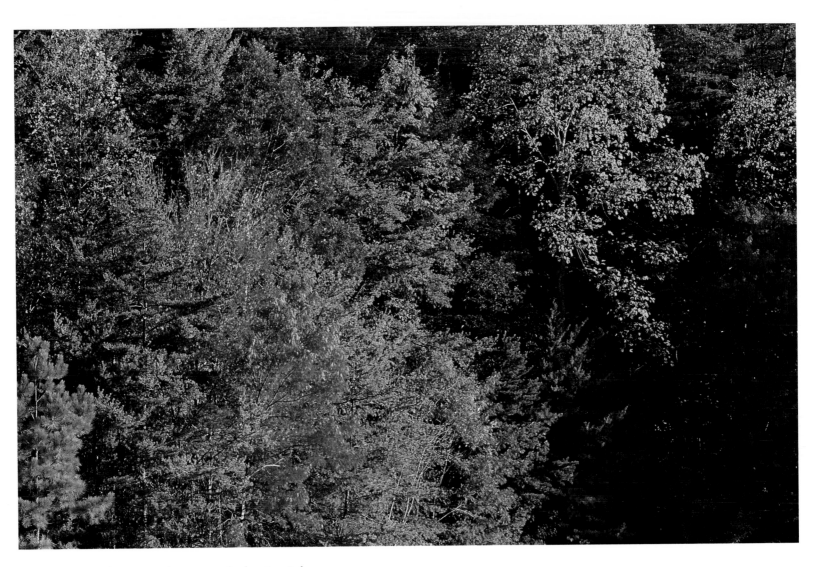

Summer greens and autumn reds announce the changing of the seasons.

A blazing red water oak leaf against a blue morning sky.

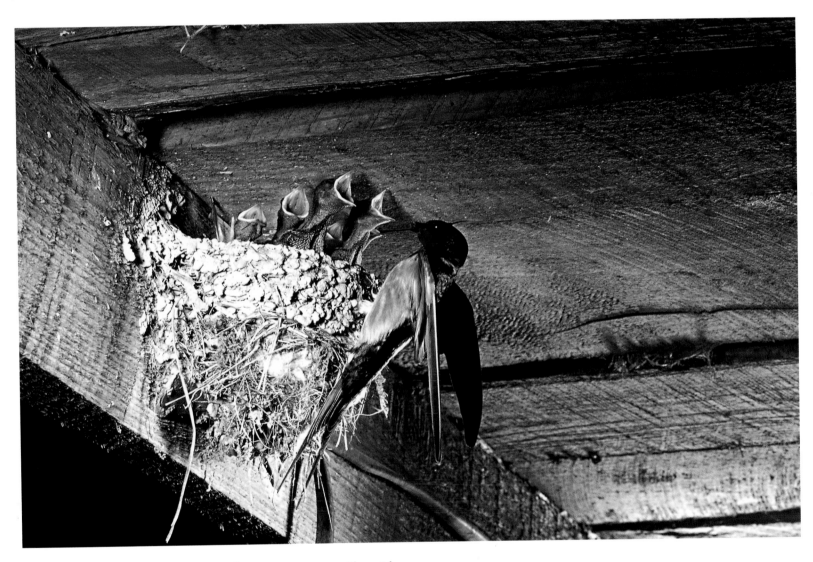

Young barn swallows stretch with mouths wide open in anticipation of being fed.

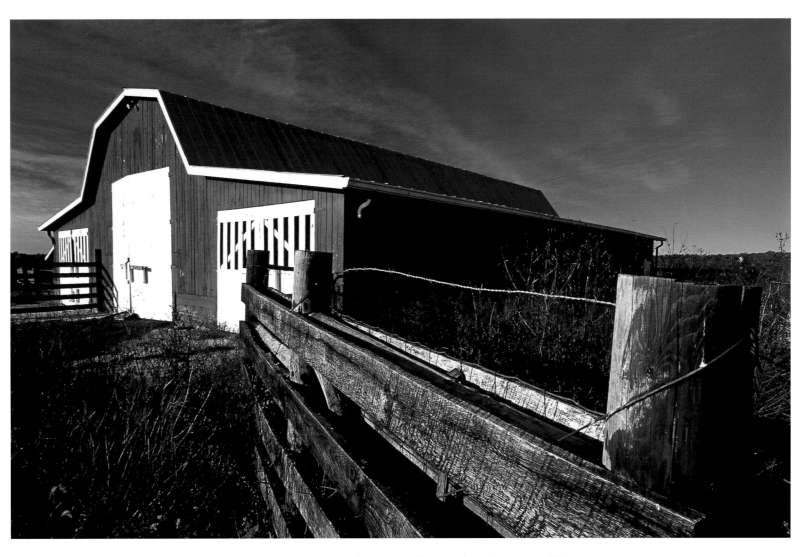

The barn at Chestnut Mountain Ranch is used for storing tractors that till the open fields, now planted to attract wildlife.

A Snake in a Brown Paper Sack

Back in the eighties, I don't know what year it was, TWRA [Tennessee Wildlife Resources Agency] and a bunch of us decided to form a club because there was poachers and spot-lighters on the mountain. We caught a bunch of them. Anyway, we decided to put us a booth up at the county fair in the fall of the year. Somebody got the bright idea of putting in a snake pit. So it fell back on me and Bill to catch the snakes.

We started going around the old rock quarries and the breaks of the mountain and around the bluff lines where old rattlesnakes and copperheads den up. We had an old pasteboard barrel with a lid and caught about twelve to fifteen of them and carried them around in the vehicle until we could unload them. We carried a minnow bucket in our truck all the time in case we came up on a snake.

One day me and Bill were over in Van Buren County checking the back of Bridgestone property and we run across a five-foot-long chicken snake—

WILBERT LAYNE

it's really a rat snake—in the middle of the road, and we didn't have anything to put it in but a little paper sack. We crammed that snake down in there and I took a little piece of wire and tied it off. We were going off the mountain and that old snake was trying to push up out of the sack. All of sudden that old sucker's head shot right up in my face. I grabbed it behind the head and old Bill almost wrecked. Then that snake got wrapped around the coil underneath the seat and around my legs. I got him loose but not without a struggle.

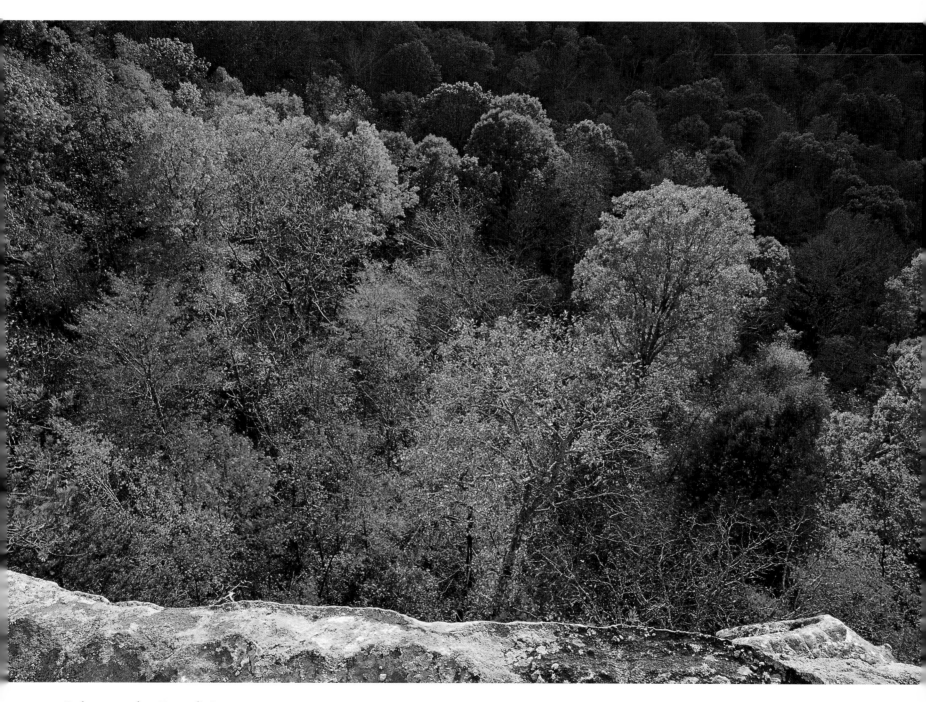

Rock outcrops along Buzzard's Roost.

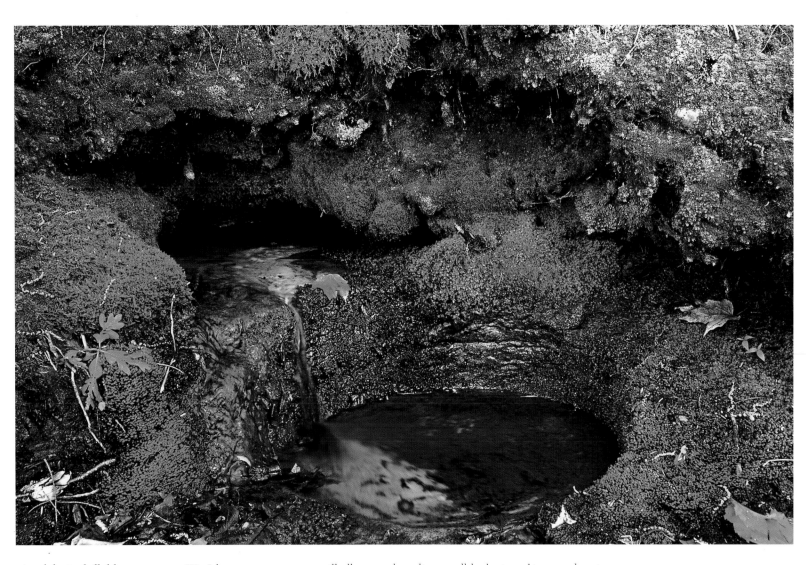

A rock basin drilled by stone carver Wes Johnson many years ago still allows people to dip a small bucket into this natural spring.

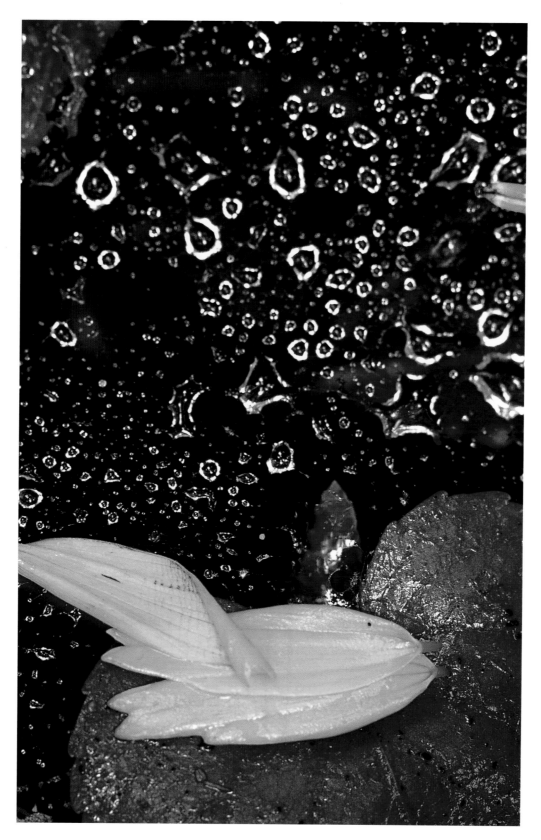

Yellow flower petals and morning dew cling to a spiderweb.

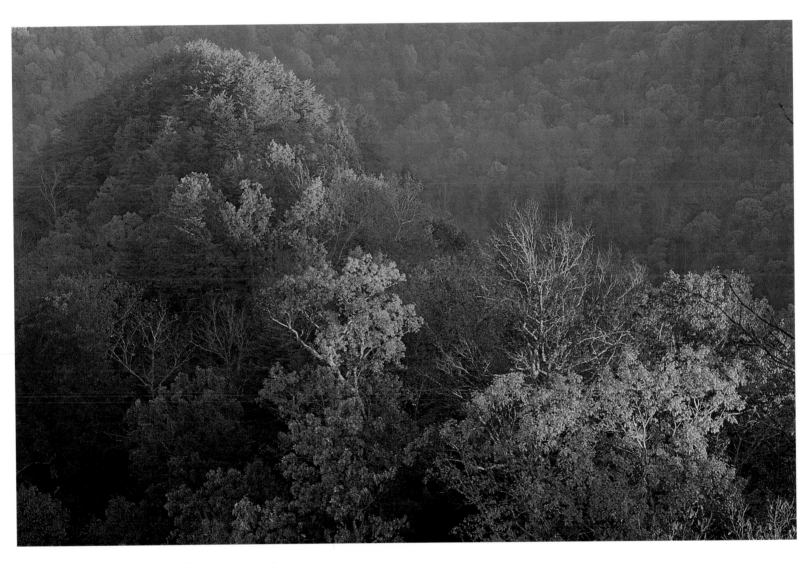

Early morning light plays off the ridges below Buzzard's Roost.

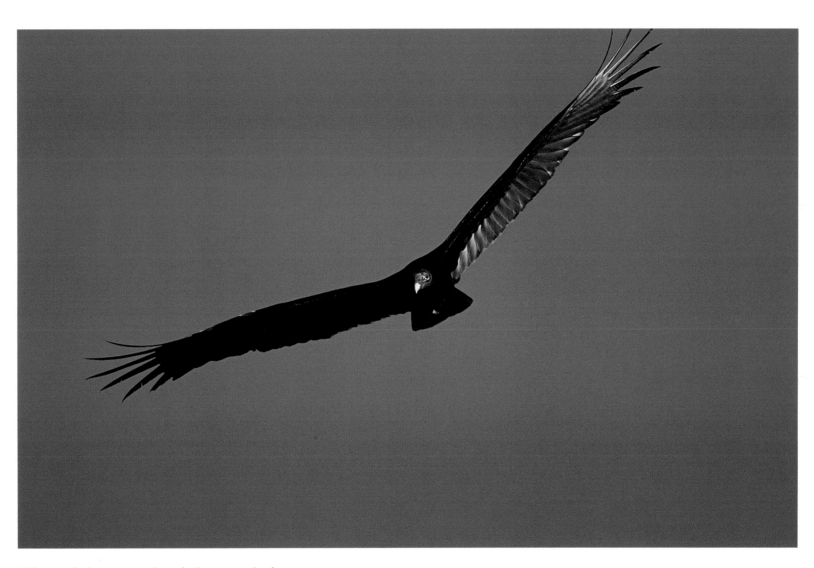

Vultures ride the warm air thermals that rise up the plateau.

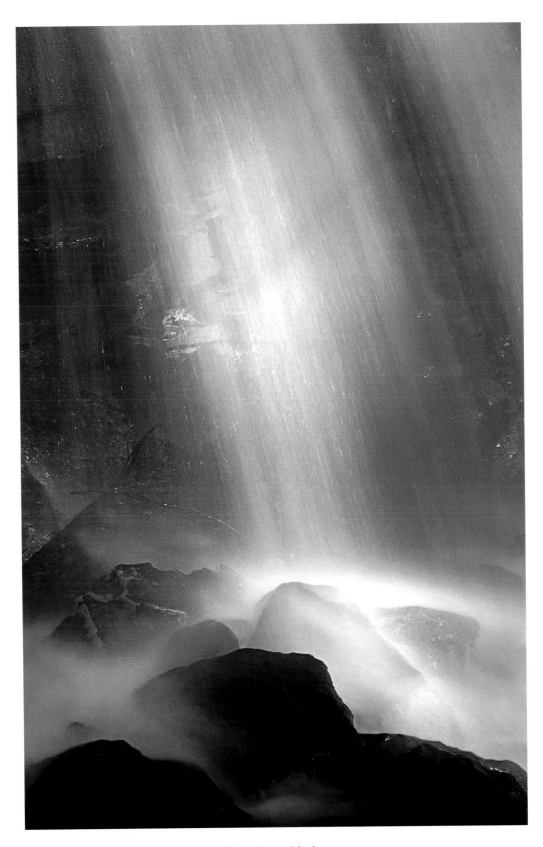

Polly's Branch Falls, one of the few waterfalls with a trail leading to it.

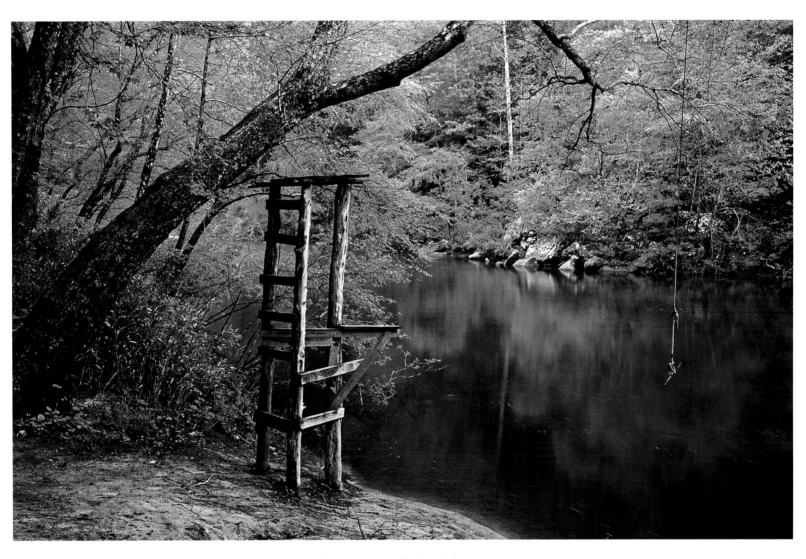

Known by a variety of names, Boat Hole is the area's most popular swimming and fishing hole.

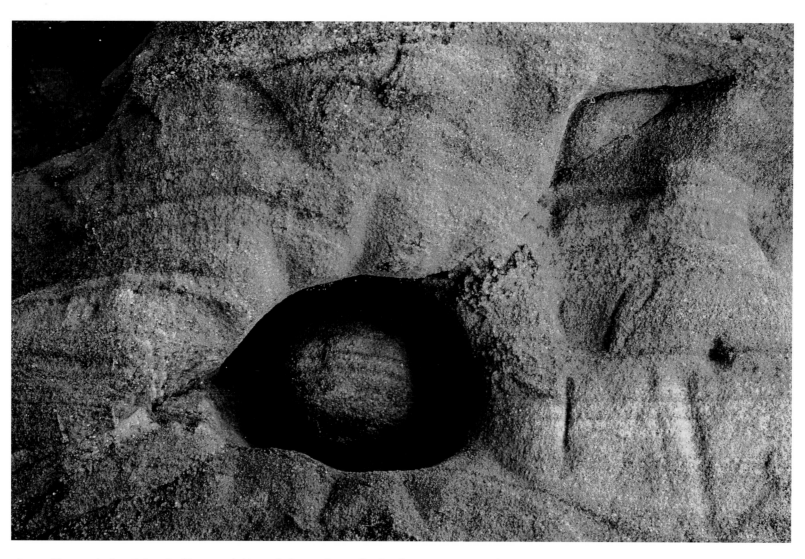

An eye-like petroglyph at Indian Rockhouse, probably made during the Woodland and Mississippian periods.

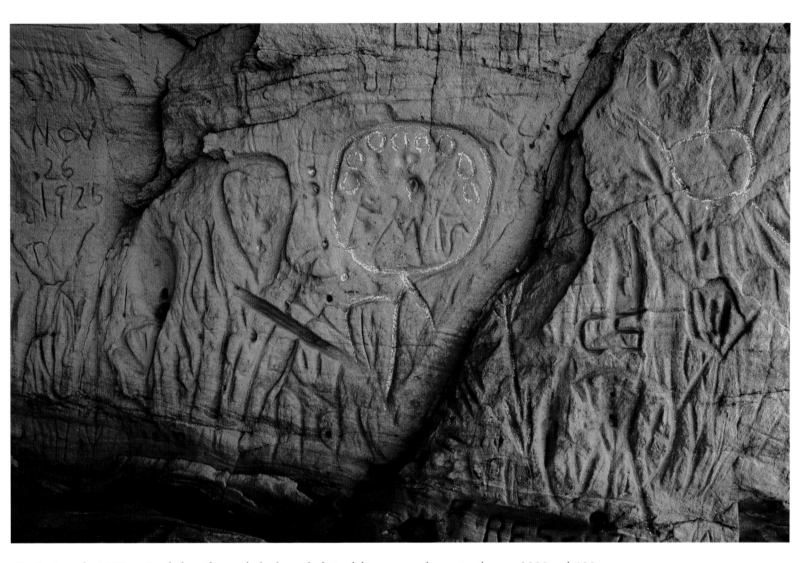

Graffiti from the 1920s is found alongside petroglyphs that archeologists believe were made sometime between 3000 and 600 years ago.

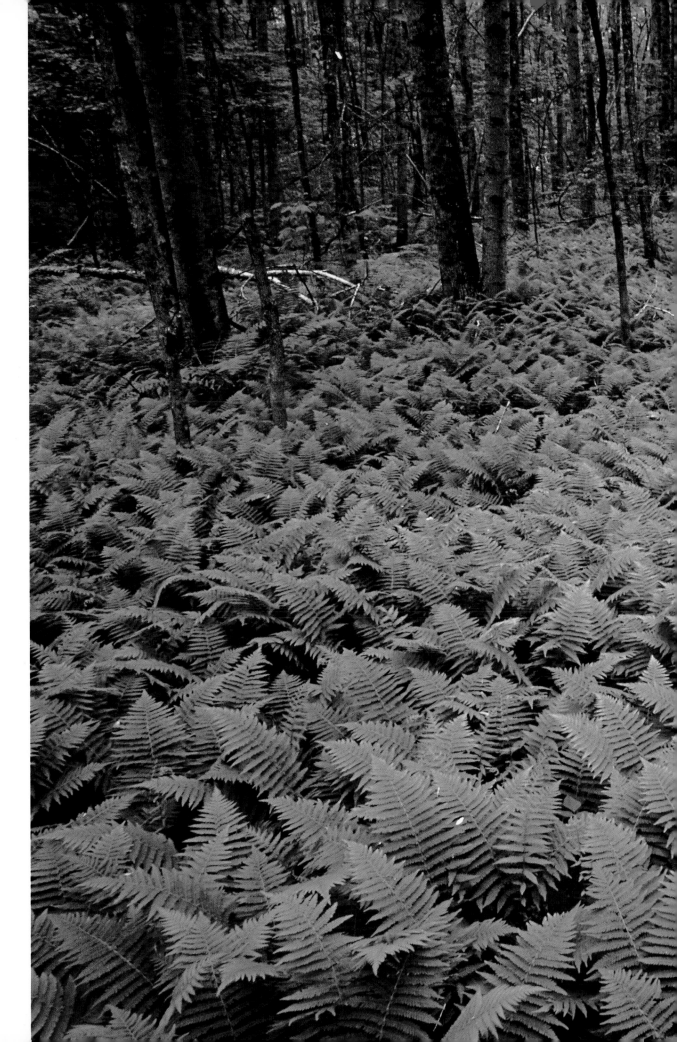

Ferns grow thick in a temperate climate with plentiful rain.

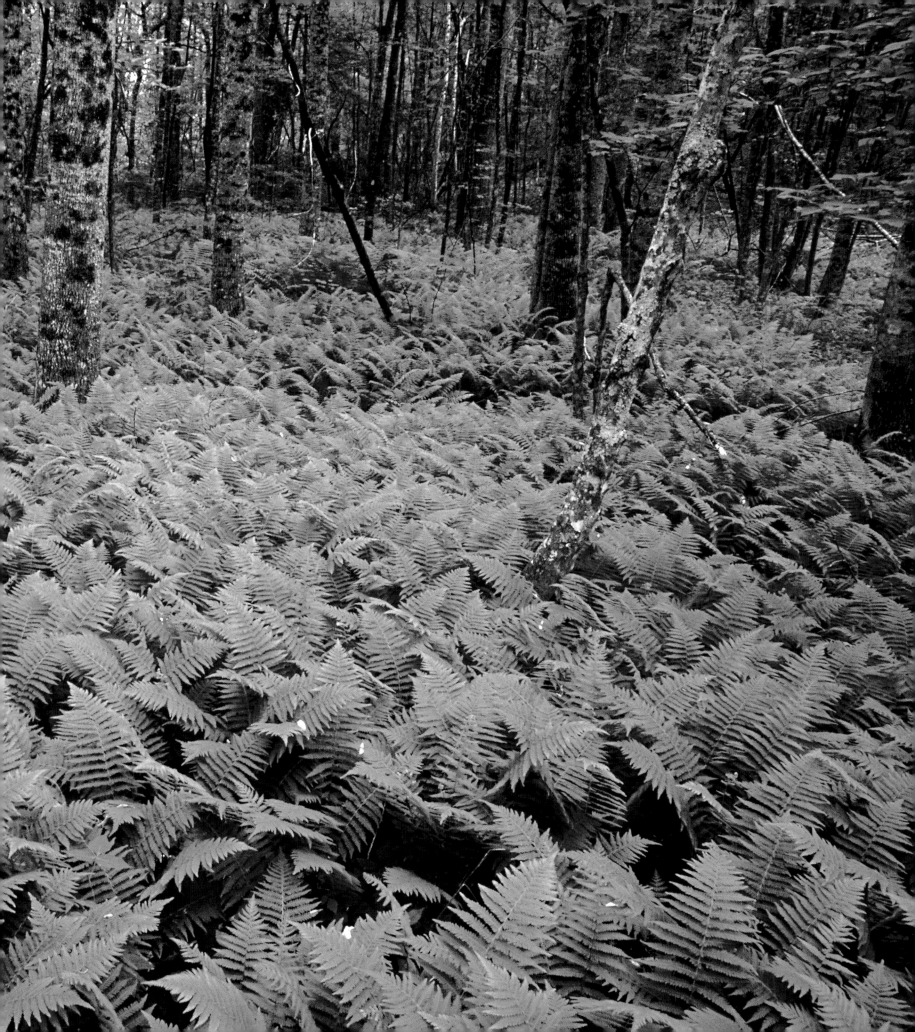

Low water levels during dry months allow access across the otherwise unfordable river.

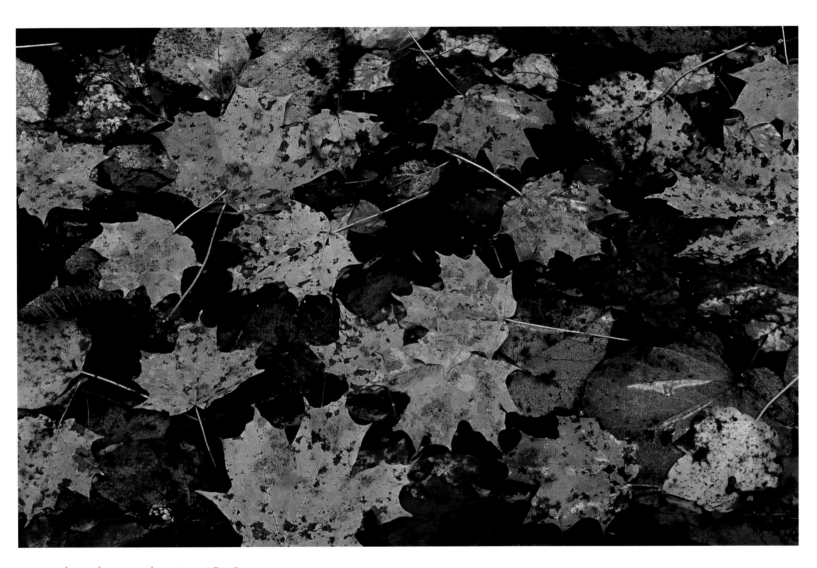

Autumn leaves floating on the surface of Big Springs.

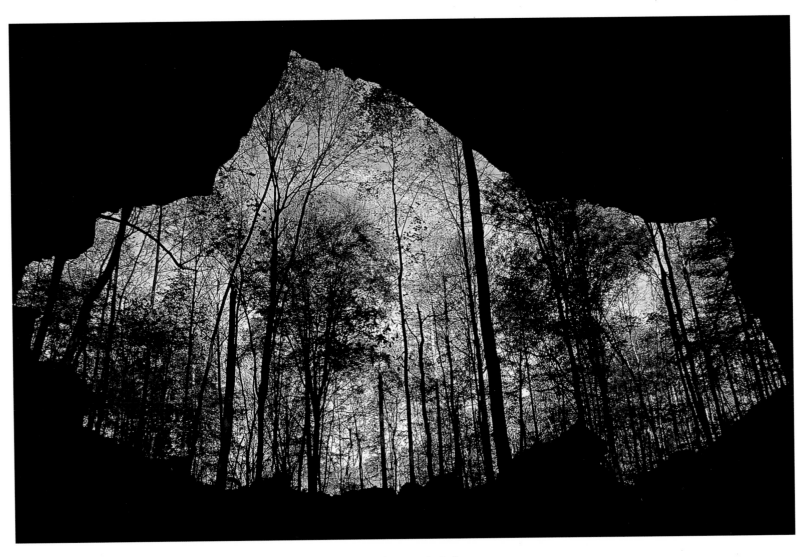

The view from inside Rose Cave, one of the largest of many caves found throughout Scott's Gulf.

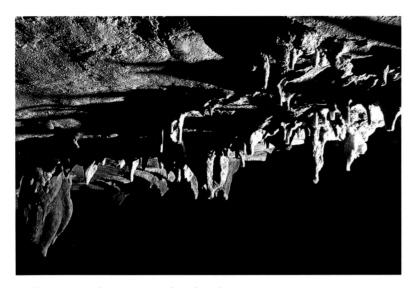

Stalactites, formed over centuries by calcite deposits.

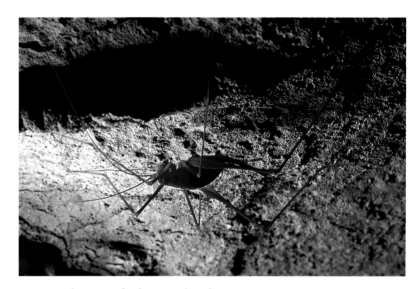

A cave cricket moves slowly across the ceiling of a cave.

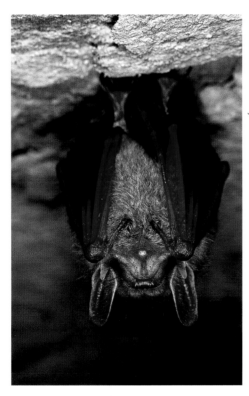

The Eastern pipistrelle is one of many species of bats that populate area caves.

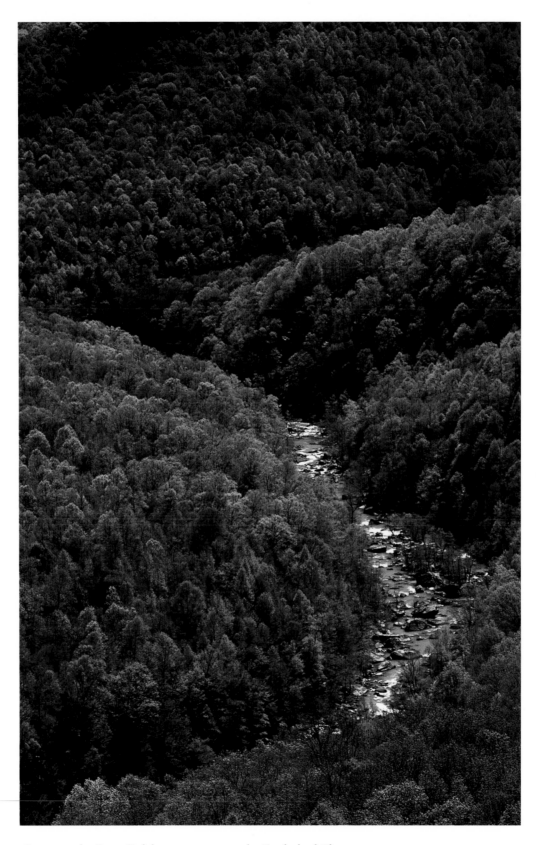

Over time, the Caney Fork has cut a gorge into the Cumberland Plateau.

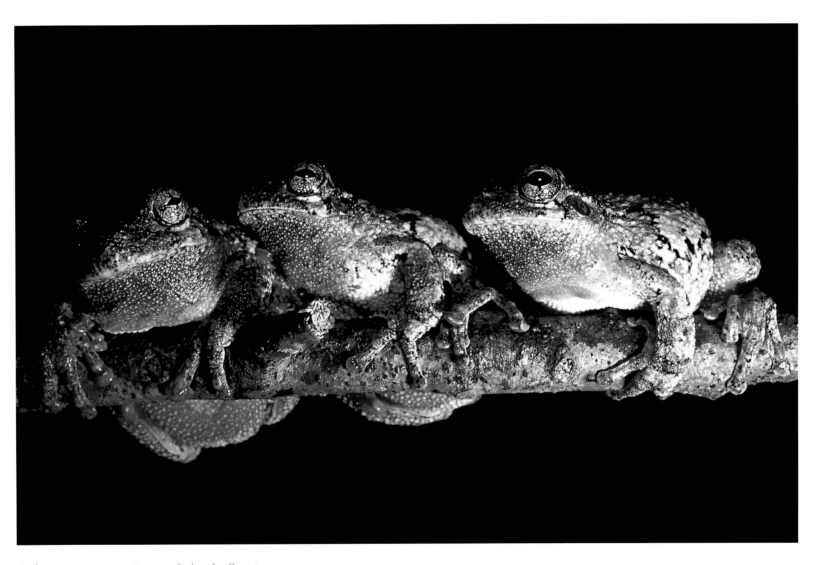

In late spring, gray tree frogs can be heard calling for a mate.

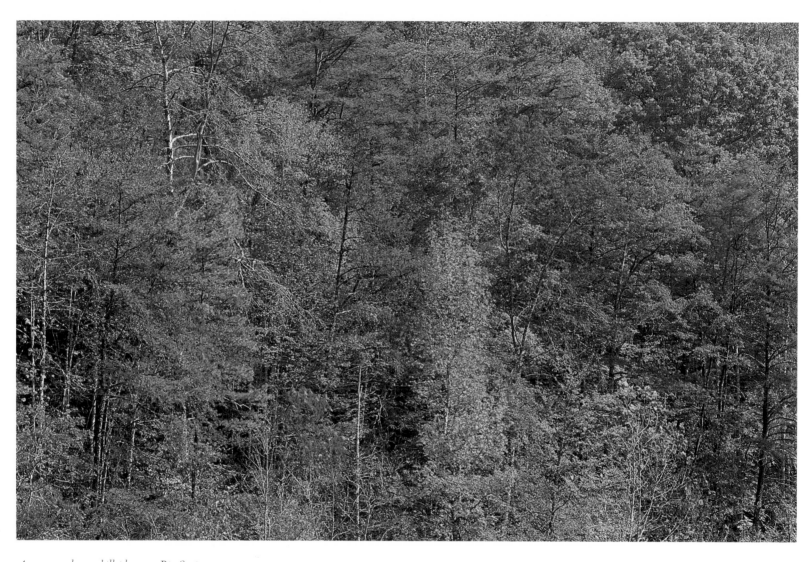

Autumn colors a hillside near Big Springs.

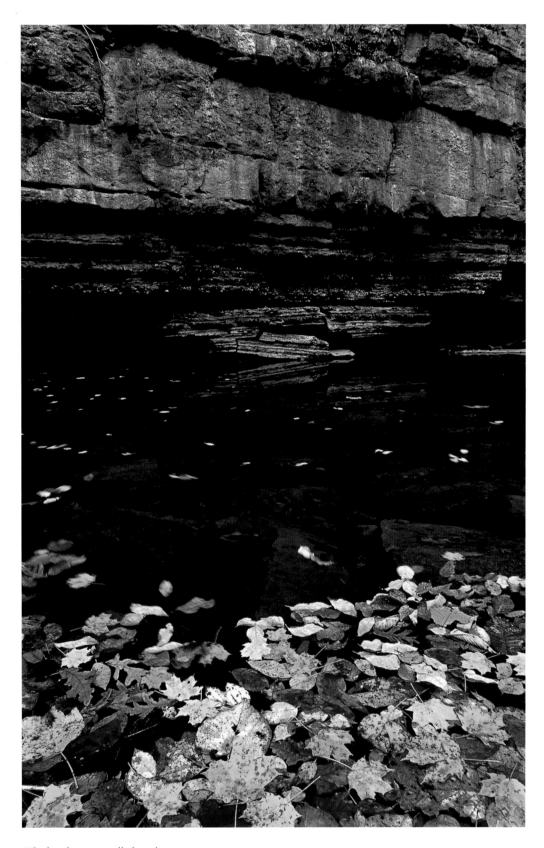

The last leaves of fall float downstream.

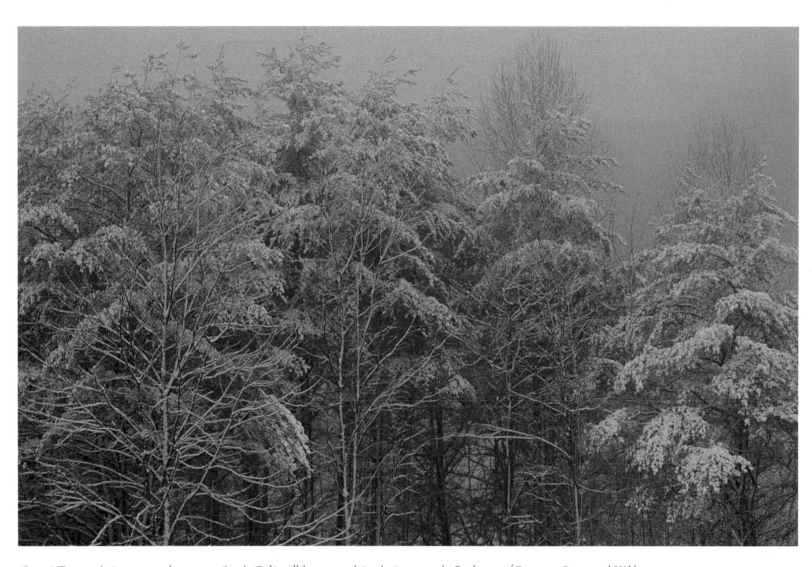

One of Tennessee's finest natural treasures, Scott's Gulf will be preserved for the future as the Bridgestone/Firestone Centennial Wilderness.